Secrets of
STUDIO STILL LIFE
Photography

Secrets of **STUDIO STILL LIFE** Photography

By Gary Perweiler

AMPHOTO
American Photographic Book Publishing
an imprint of Watson-Guptill Publications/New York

Text by Kathryn E. Livingston

Photographs on pages 8–15 by Robert Lorenz

First published 1984 in New York by AMPHOTO,
American Photographic Book Publishing, an imprint of
Watson-Guptill Publications, a division of Billboard
Publications, Inc., 1515 Broadway, New York, NY 10036

Library of Congress Catalog Card Number: 84-045063

ISBN-0-8174-5897-2
ISBN 0-8174-5898-0 PBK

Distributed in the United Kingdom by Phaidon Press Ltd.,
Littlegate House, St. Ebbe's St., Oxford

Manufactured in Japan

1 2 3 4 5 6 7 8 9/89 88 87 86 85 84

CONTENTS

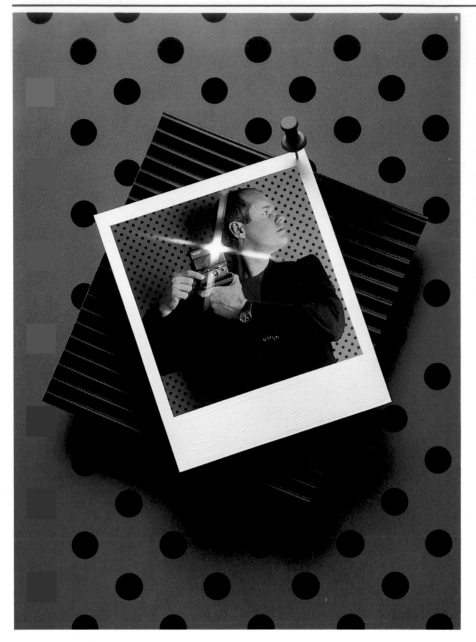

I was basically educated as a designer rather than a photographer. I studied graphic design at the Philadelphia College of Art for four years, largely with Swiss designers, and I discovered that I had a propensity for design.

When I started out, I worked for one fashion photographer. Then I worked for myself. I learned the hard way: by *doing* the work.

In most cities you have to know how to do a lot of things to be a commercial photographer. In New York, you have to specialize. You're more likely to succeed if you just try to do one thing well. So I specialize—in still life.

Being a studio photographer involves more than taking pictures. There's a lot of business to attend to. The bigger you get, the more money flows through your business, the more you need people to take care of matters for you.

So, I employ a bookkeeper, a secretary, accountants, and a lawyer. I have a studio manager, and a production person who works closely with my reps and schedules the jobs, making sure that everything is ready on time for the shoot, and who communicates directly with the art directors. I also have several assistants who work with the studio manager and me. I have a tutorial relationship with my assistants. Whatever they can learn from me, they will eventually be able to use in any area of photography.

Two reps work for me in New York, one in Chicago, and one in Germany. Their job is to take my work out and show it to art directors and agencies. I think a rep is the most important link between the agencies and your bank account. You need a good rep, or group of good reps, out there, pounding the pavement every day, to assure that the work continues to come in.

The portfolio a rep shows is important. Your portfolio should be a reflection of your own ideas. It should look distinctive, and it should have a point of view. You should be as creative as you can be in putting together a portfolio, but you still have to realize that it's a *commercial* portfolio, if commercial work is what you want to do.

Advertising is important, too. Something should cross an art director's desk every couple of months to remind him of what you do. The crux of getting

jobs is *timing*, having your book, your rep, even a mailer, in the right place at the right time.

I think any photographer should be a still life photographer for awhile, because the still life studio photographer really learns how to do lighting. And the more you do studio work, the easier it becomes to get a shot done. There comes a point when you just look at an object and *know* what the problems will be, before the lights are even turned on. At this point in my career, I feel there's nothing I can't photograph!·

Studio still life work relies a lot more on technique than, say fashion, which is a more spontaneous area of photography, where the action in front of the camera and the energy coming from the models is important. If you're photographing still life, there's usually no external energy. You have to *make* the energy. It's a problem-solving area, really. You have to learn to solve the problem of making the product look good.

There's another reason why I recommend still life photography for the beginner—a still life shot is less expensive to produce in terms of overhead. The props involved and relative studio space needed are small in comparison to other types of photography, but the time pressures are just as great. If you are a beginner, starting out in fashion work, you have to worry about the time for the models, hair stylists, dressers, and other extraneous personnel. You not only have to shoot fast, you also have to be accurate, because retakes are very expensive. With still life you have a little bit more flexibility. If a shot doesn't work the first time, there's a good chance that you can make some changes and try again.

I do advertising photography primarily—national ads created to *sell a product*—as well as some editorial photography that generally involves "telling a story" about a place or situation. Advertising photography is very structured. Within certain limits, the photographer can be creative and use his own ideas, but you can't do what the advertiser *doesn't* want. When a business buys space in a magazine, they spend a lot of money, and don't want to take any chances with what goes on that page.

When an art director in an agency has a product to advertise, producing that ad is preceded by a lot of market research to determine which product is the best to show, which color or flavor, etc. Then the art director generally pays my day rate for a day of testing, and I take several photographs which the agency "dummies" up into ads. These are sent to "focus groups" where people respond and tell the agency which ad they think is the most effective. When the agency has made a final selection, what I have to do is fairly cut-and-dry.

At the same time, when an art director is buying my time, I feel that he should also be buying my style. Most professional photographers do have a distinctive personal style, and it should be assumed that you've been chosen for a job because of that style. So while advertising is, to a certain extent, a rigid area, I always try to impart my way of seeing into the art director's layout.

The production of a commercial photograph is a team effort, and everyone involved has to be a part of the team. The art director has to be able to trust the photographer to do the right thing, just as the photographer has to be able to depend on his or her own personnel to get the job done right.

When a layout has been finalized, an estimate must be approved, so I have to plan my part of the sequence. I call up a model maker if necessary, and figure out how to do the job and what it will cost. When the estimate is approved, I pre-plan the actual shot. I look through various lenses at a mockup of the shot, select an appropriate lens, and determine what scale models and objects have to be in. A stylist has to get all the props and other materials needed. It takes a lot of planning, building, and effort to set up a shot.

I'm most comfortable working with an 8×10 view camera because it facilitates design in photography. Because of the size of the negative, if there's retouching to be done, it can be done on the actual chrome, and the reproduction quality of an 8×10 is much crisper than that of a 35mm negative.

Sometimes it's harder to work with a view camera, because you have to move it up, down, focus and refocus,

set the tilts and swings, and recalculate exposures every time the bellows move in relation to the film plane. Often I use a 35mm camera to plan a shot, and to check camera angles before I move the 8×10 in. For testing or doing a very large number of shots in one day, I often use 4×5 because it's faster and more economical.

You can shoot still life studio work with a small format camera, if you attach a bellows unit, and adjust to the reduction of scale of the image in the viewfinder. Small cameras can be much more spontaneous, and they have a wide assortment of lenses available. With 35mm you have as much control of reflections, but less distortion control. A large format view camera, with its tilts and swings to correct distortion, is my preference for commercial photography.

Unlike fine art photography, advertising photography is a commercial art—and commercial art is *public communication*. Everyone who sees the ad has to understand what the picture is about, or it won't sell the product. If it doesn't sell the product, it fails. And so have you.

At the same time, though, if you don't take any chances as a commercial photographer, you don't learn anything. You just keep perfecting whatever it is that you've done before. That's boring. There are many photographers who take the same pictures over and over, just changing the subject matter. I try not to do that.

A painter friend of mine often says that the most important part of being creative is enthusiasm, and there is certainly a dichotomy in between satisfying the client's needs and satisfying your own creative instincts. Many times it is worth it to take on a job that pays less money, but allows you total creative freedom—it's a great way to prevent your work from becoming boring, both visually and to yourself.

Advertising photography is an exciting business, but it is also a highly pressured field. Every day I have to go into the studio and hit a home run and take a wonderful picture that will make art directors and their agencies and clients happy. There's an old cliche, simple, but true: You're only as good as your last job. Today's great shot is what keeps the work coming in.

LIGHTING EQUIPMENT

A **Strip light** containing one 5,000-watt flash tube, used for long, narrow highlights and for graduated lighting.

B **Medium bank light** containing two Z-shaped flash tubes totalling 10,000-watts, most commonly used because of its convenient size.

C **Round-headed light** with 5,000-watt power, used to create halation and other circular lighting effects through a diffusing material.

D **Square-headed light** with 5,000-watt power used to produce straightened highlights.

E **Small bank light** with 5,000-watt tube, simply used for lighting small subjects.

F **Large bank light** with 5,000–20,000-watt capacity. Its four separate flash tubes may be separately brightened or dimmed for a modeling effect. Not often used for small setups because of its 5 × 6-foot size.

G **Strobe power unit** capable of producing fast, short impulses of light, used in multiple exposures and for capturing motion on film.

H **Snoots** used to shape and direct light by placing them over light sources. From left to right: *Large cylindrical snooot* narrows light into a fairly wide, concentrated beam. *Cone-shaped snoot* directs light into a narrowed, smaller beam. *Small cylindrical snoot* narrows light into a smaller beam. *Metal extender snoot* is placed over a small head to extend the distance of the diffusion material from the flash tube.

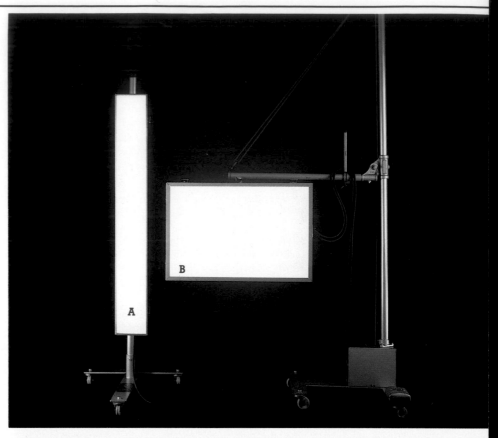

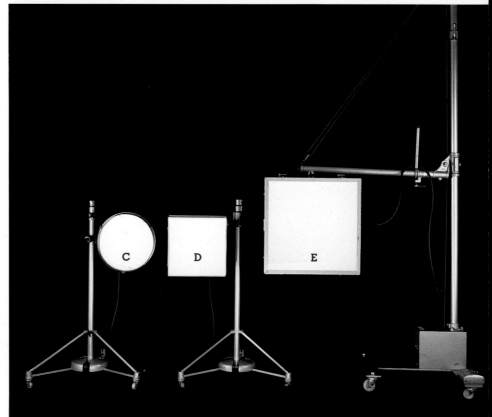

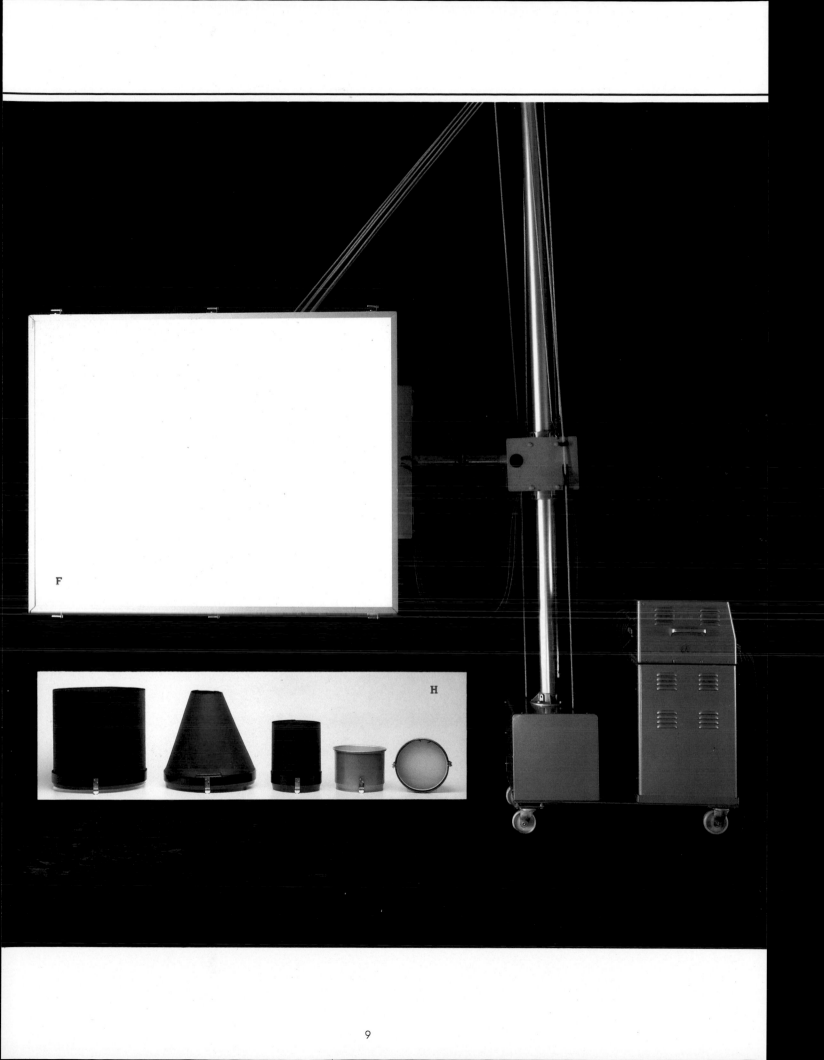

FILTRATION

A collection of color compensating (i.e., correction) filters for color work, color conversion and contrast filters for black-and-white work.

A 80 A color conversion filter used to adapt daylight film to tungsten type B use.

B Neutral density filter used to decrease the amount of light reaching the film.

C .10 color compensating filter

D .30 color compensating filter

E .025 color compensating filter

F Filter frame

G No. 25 red filter for increased black-and-white contrast.

H Gray card, gray scale, and color patches used to establish the contrast range in black and white, or, in the case of color patches, to achieve true color.

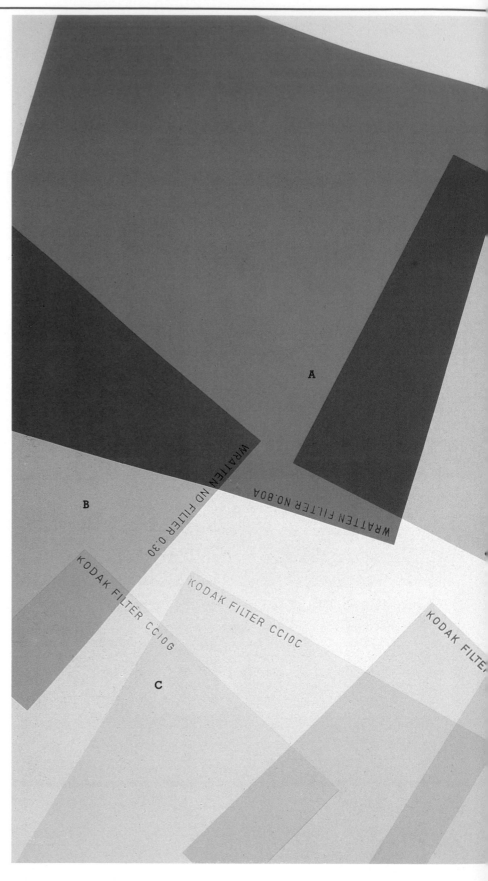

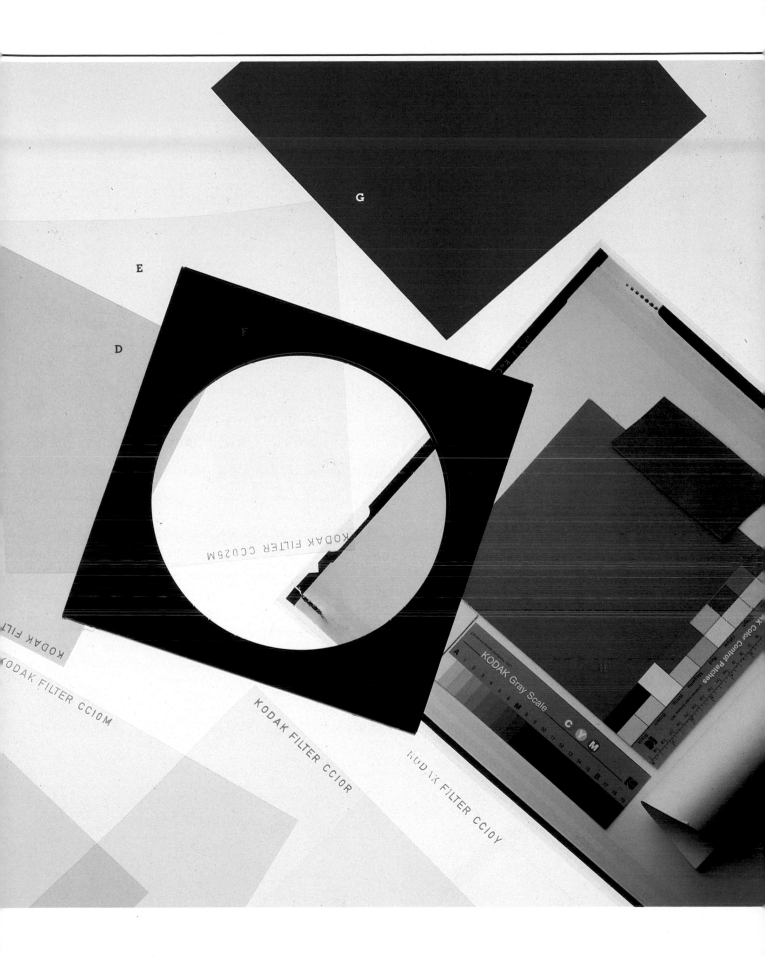

BACKGROUNDS

A Black grid Formica (background) for a textured black background.

B Shiny black foil board for softer reflections.

C Black Plexiglas

D Lined white Formica, used much like Plexiglas.

E White Plexiglas inhibits shadows, diffuses light.

F Shiny silver foil board

G Chrome pipe

H Plexiglas (in various colors).

I Seamless paper, the standard studio background.

J Shiny vinyl (blue and gray), for a "wet" look.

K Gray ribbed rubber mat for texture.

L Gray Ultrasuede for a matte gray background.

M Red blinds

N Black painted pipe

O Gray diamond-plate rubber mat

P Black tile to create black-on-black grid background.

Q Black velvet for a rich, matte black.

R Knobby black rubber mat

S Gray Perelli tile

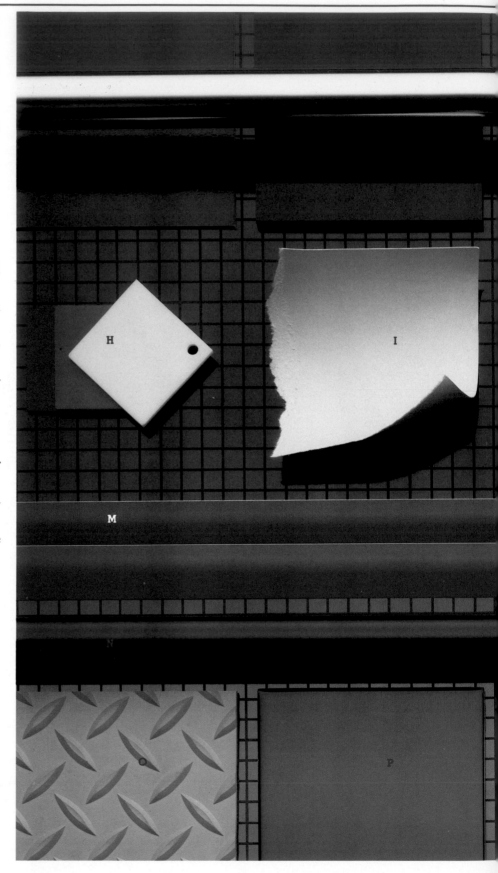

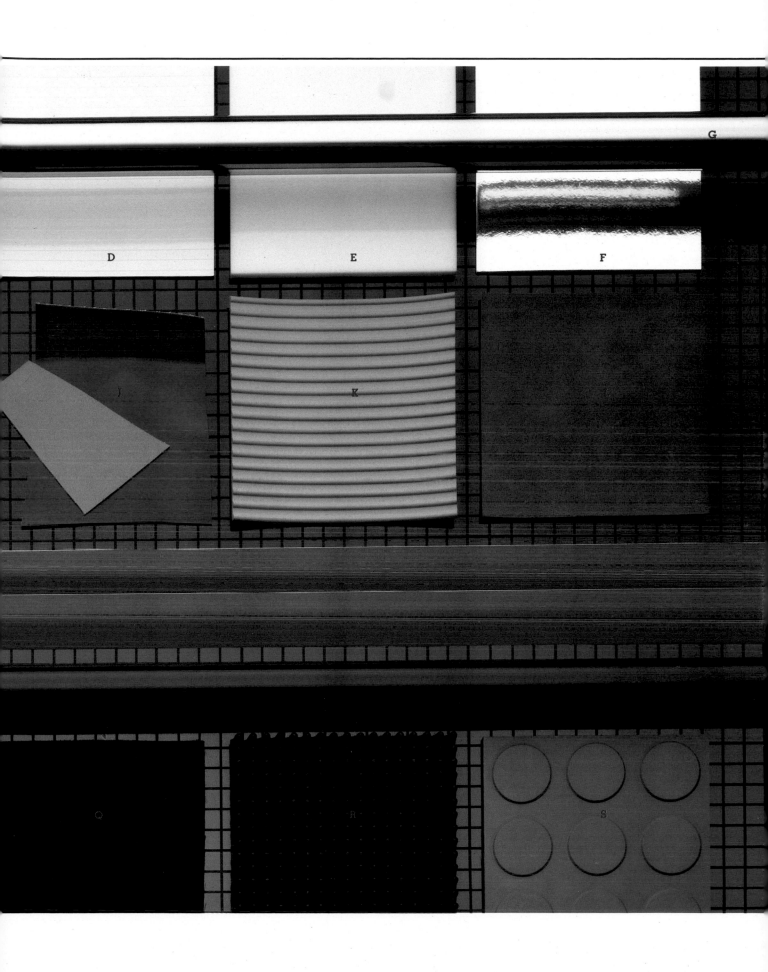

TOOLS AND AIDS

Various aids and tools commonly used in the studio or in setups.

A Proportional scale used to determine sizes when enlarging or reducing proportionally.

B Scaleograph used to enlarge or reduce a square or rectangle proportionally.

C 5-minute epoxy glue, a quick-drying, secure adhesive.

D Glycerine used to simulate water and/or liquid sheen.

E Plastic rod for stirring liquids.

F Scissors

G Level, used in set construction.

H Dividers, used for measuring.

I Monofilament for invisibly suspending objects.

J Armature wire, used to make objects stand up, support fabrics, etc.

K Razor knife

L Tweezers for handling small or delicate objects.

M Paper clips to hold backgrounds in place, keep folds in fabric, etc.

N White gloves to prevent fingerprints on surfaces.

O Brushes

P Plastic pieces, used as supports for small objects.

Q Drills for glass

R Cotton tip

S Eye dropper for placing drops of water or glycerine.

T Can of spray paint, and adhesive, matting, and glossing sprays

U Plastic, photographic, and double-stick tapes

V Plastic tubing

W Anti-static gun

X Fun Tak temporary adhesive.

Y Solvent

Z Surface cleanser

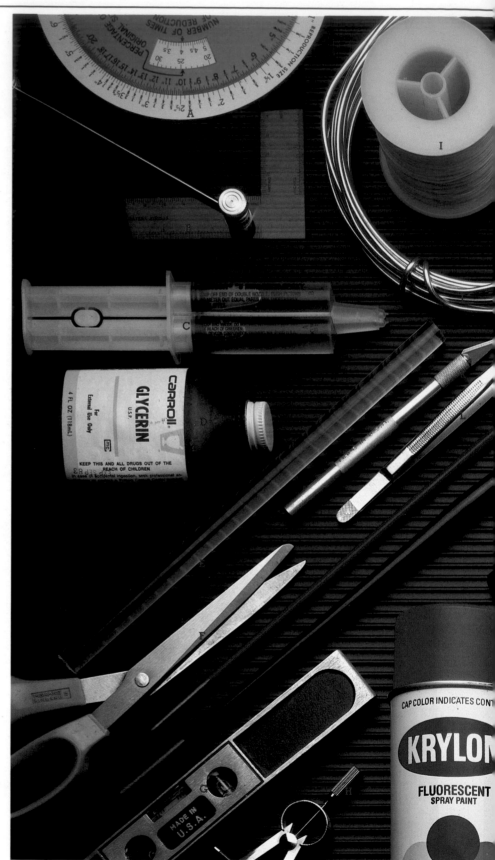

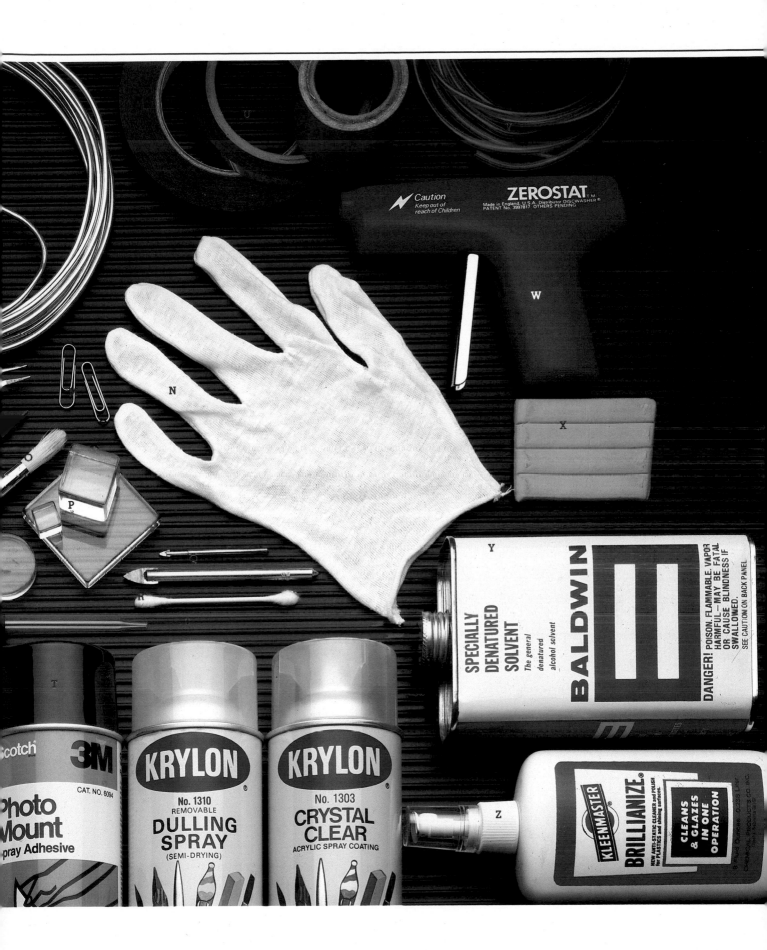

Part One
THE IMPACT OF DESIGN

These days anybody can pick up a camera, snap a sunset, and make a pretty picture. And many people think that's all there is to making a photograph. But the truth is, beautiful photographs are beautifully designed, and design is a discipline, not a matter of luck.

I studied Swiss design, and am steeped in the traditions of that school of thought. There are some very basic design rules that every good photographer is aware of, but knowing how to choose colors and shapes and make them interplay on a page isn't all you need to understand. My pictures are very pristine—some might even say they are rather cold. But that's my way of seeing things, and as a photographer it's important to develop your own style and vision. In the still life field, which is very competitive, it's essential to have your own point of view—a vocabulary and style that will set you apart from the crowd. My particular style is very simple and straightforward. I don't like a lot of flotsam and jetsam in a picture. I often use only one main color, and a very basic lighting setup. But the objects, their placement, and the balance and tension that they will create are all carefully considered aspects of design.

Light is actually even more important to a photograph than design, but both are necessary components and must work together to make a successful image. The way light shines on a background, a glass, a plate, or a cup of tea can determine whether a picture hits or misses, and when you add to that light the element of design you round out an image and make a complete statement. I'm fascinated by the interplay of shapes, textures, colors, and shades of light. The way these factors interact are all part of the overall design of an image and to me the most beautiful images are those in which these elements interplay simply and elegantly, in a manner that is clear and uncluttered.

Some photographers are just interested in light. They see a beautiful sky and all they can think of is luminosity! Others, like Eugene Smith, find design as essential as light. Smith's pictures were well composed and compelling. A photographer like Weegee, on the other hand, didn't care much about design. He wanted to make a statement about the human condition, and composition didn't have much to do with what he wanted to convey. For the still life photographer, though, design is always an integral part of an image. In commercial art, the viewer must readily understand what you're trying to say, or you won't sell the product. There isn't much room for philosophy. If the picture isn't carefully composed, and if the design is thoughtless, you won't communicate your concept. The strongest and most graphic images are those in which design has played a primary role, and the power of its effect can't be denied.

AN INTERPLAY OF CIRCLES AND BARS

This photograph is an experimental shot made for the studio bathroom. I wanted to create an image that was almost totally monochromatic—a black-and-white image on color film—where the shapes of the objects would become the most important design element. I wanted to contrast the new and the old, so from about 30 faucets and a dozen stoppers, I chose this modern-looking, Bauhaus-styled faucet and a generic, old-fashioned stopper. I could have picked a more obviously designed modern piece for the faucet, but I didn't want the contrast to be too jarring, as that would overpower the main idea of this image as an orchestration of the repetitive shapes—circles and long, bar-like rectangles—in each object.

I placed the stopper, sprayed with glycerine and water, at the lower left-hand corner. The faucet was placed at the upper right to create a dynamic balance. I was fascinated by the series of shapes—the circle on the main shaft

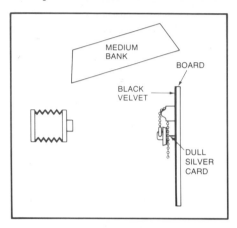

of the faucet, the circle of the screw that holds the faucet to the sink, the slot that runs across the screw, and the actual handlebar of the faucet. The stopper is a circle, its center is a bar, and the chain is a series of circles. The juxtaposition of sizes and positions of the repetitive shapes have an extraordinary visual impact.

I used a black velvet background, with one main light on top and a dull silver fill card on the bottom. I filled only the faucet, because filling the stopper would have flattened it out and destroyed the detail in the droplets.

Screw slot and bars of letter H repeat linear shape of faucet handle

Chain's beads echo other circular shapes

Chain connector echoes handle's linear shape

Droplets add a less formal note

Glycerine-water mix used to prevent running

Stopper placed at lower left balances bulk of faucet at upper right

Chain goes off edge, anchoring image

Black velvet background goes solid black

Faucet attached to board behind velvet

Main highlight from overhead light

Lesser highlight from dull silver fill card

Faucet base repeats circular shape of stopper

Ring repeats circular shapes of stopper and faucet base

Ring selected that just fills half of stopper

Metal of ring and chain tie them to faucet

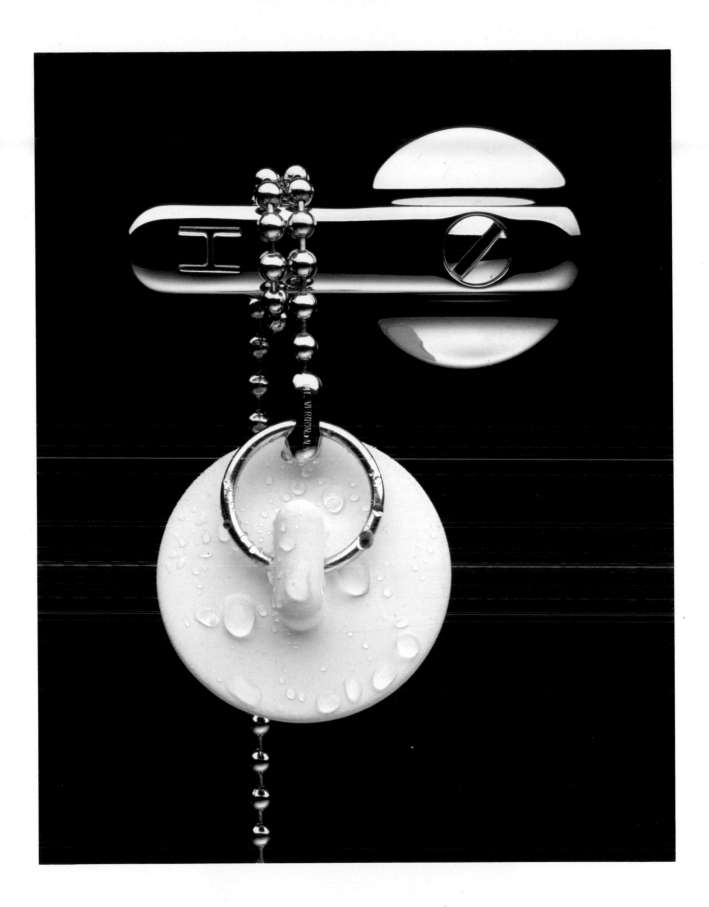

THE DOMINANCE OF BRIGHT COLOR

In this sample shot, made for my portfolio, I wanted to create a visually exciting image using an ordinary, every-day subject. To make this cup of tea appear as something special, I began by making the liquid in the cup an unusually bright color, and then chose the other elements in the picture to highlight and accentuate the tea.

The liquid in the cup is actually distilled water colored with food dye. The only other element with strong color—the lemon—is closely tied to the tea. Along with the propeller-shaped sprig of mint, it adds tension to the image because of its asymmetrical placement, yet at the same time it complements the highlight within the cup.

The square shape of the saucer adds interest to the arrangement and prevents the strong circle of color from becoming a bull's-eye. I placed

the sugar cubes slightly askew, so that the image would look more casual, and added bubbles to the milk to give it a freshly poured look. The milk is really mostly glycerine, with just enough milk mixed in for color. The bubbles in real milk would have burst in a matter of seconds.

The spoon and the napkin anchor the image to one edge of the frame, and their pointed shapes direct the eye toward the cup. This is a subtle, but important, design technique, because when you are shooting an advertisement, you want all of the elements in the frame to emphasize the product, not detract from it.

I placed everything on a background of black ceramic tile, which reflected the light and held the shad-

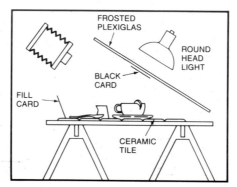

ows and reflections of the dishes. The horizontal lines of grout in the tile reflect darker than the tile's ceramic surface, adding depth to the picture. There is a center line of grout running vertically up the center of the picture, but I hid it under the cup and napkin to emphasize the two horizontal lines.

I wanted the subject to be in a pool of light, surrounded by darkness along the edges, so I used only one light, placed overhead, fairly close to the subject. I put a large sheet of plastic in front of the light to act as a diffuser and get that nice, gradual transition between the light and dark areas. A fill card was placed near the camera to produce the highlight along the front edge of the saucer. I taped a small card to the plastic diffuser to create the small, crescent-shaped reflection in the tea. This blocked the light reflected by the rest of the tea.

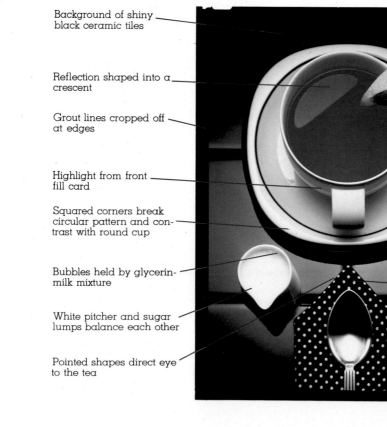

Background of shiny black ceramic tiles

Reflection shaped into a crescent

Grout lines cropped off at edges

Highlight from front fill card

Squared corners break circular pattern and contrast with round cup

Bubbles held by glycerin-milk mixture

White pitcher and sugar lumps balance each other

Pointed shapes direct eye to the tea

Lemon and mint add off-balance interest

Distilled water with orange food color

Pool of light from round-headed strobe

Light's edge softened by frosted plastic

Different-shaped sugar lumps casually arranged

Napkin hides vertical line of grout

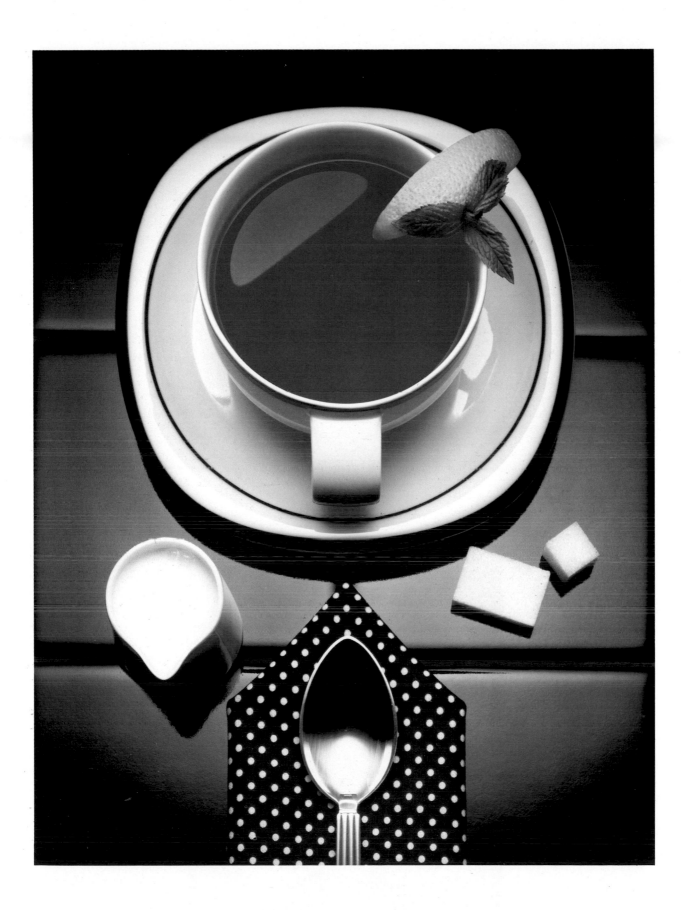

A TRIANGLE OF FOOD VERSUS A CIRCLE OF SODA

Probably no food is more mundane than the hot dog, so it was a challenge to create an interesting still life with this ordinary food as its most important element. Though I wanted the hot dog to dominate the shot, I also wanted the other visual elements to be exciting, so I was especially careful to ensure that all parts of the set would be in crisp focus. Large magnification, achieved by using extension with the view camera, creates a very shallow depth of field, and in order for all parts of this picture to remain in focus, they had to be positioned pretty much on the same plane.

Because the hot dog was the central element, I took special care to make it appealing. I placed it on a square plastic plate and positioned the plate so that its corner created a triangle. I thought the geometric shape would juxtapose nicely against the circular glass in the foreground. I went through about ten dozen hot dog buns before finding these two tops that matched perfectly to create a uniform roll. The inside of the roll was brushed with Kitchen Bouquet to provide a golden toasted color. The hot dog was pan-fried to an appetizing brown, lacquered to make it shiny, and squiggled with mustard for character and color. My main concern was to overcome the depth-of-field problem, so the hot dog and plate were raised with a clamp to the same level as the top of the glass.

I wanted to be sure that the top of the glass would be in focus, so the glass itself was wide and very short to accommodate the limited depth of field. I added two striped straws to brighten up the negative space on the side of the glass, one extending out of the frame and one breaking up the white space. A pop-top cap, mounted on a rod so that it too would be in sharp focus, was used to break up the space on the left. I added some bubbles and a Lucite ice cube to avoid a flat-looking cola.

No hot dog is complete without french fries and pickles, so I didn't want to leave them out of the picture. The roll, hot dog, catsup, and straws all tied into the overall red color scheme, and the yellowish green of the pickles went well with the mustard and fries. I also arranged the food to form a triangular shape, echoing the plate edge, so that a series of triangles point toward the circular glass.

The lighting for this shot was pretty straightforward. The set was placed on frosted Plexiglas with a bottom light that brightened the soda and plate. I also used an overhead light for the food. The difference in exposure between the lights was about ½ stop, with the bottom light kept brighter for clean whites.

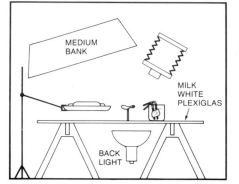

MEDIUM BANK

MILK WHITE PLEXIGLAS

BACK LIGHT

Food massed to form strong triangle pointed against semi-circle below

Hot dog positioned to form strong central subject

Hot dog pan-fried and lacquered for correct color and sheen

Squiggle of mustard adds color and interest to central subject

Frosted Plexiglas background evenly lit from below

Pop-top ring fills dead space and repeats circular motif of glass

Unseen rod under ring raises it to level of top of glass to be in focus

Glass positioned to form perfect half circle

Lucite ice cube and bubbles break up soda's uniformity

Catsup repeats the straw's red

French fries and pickles complement color of hot dog

Two hot dog bun tops matched for symmetry

Inside of bun brushed with Kitchen Bouquet

Square plate angled to form triangle echoing food

Plate's curved corner echoes arc of glass below

Plate elevated to level of top of glass to be in focus

Straws fill dead space, adding color and off-center interest

Very short glass to accommodate limited depth of field

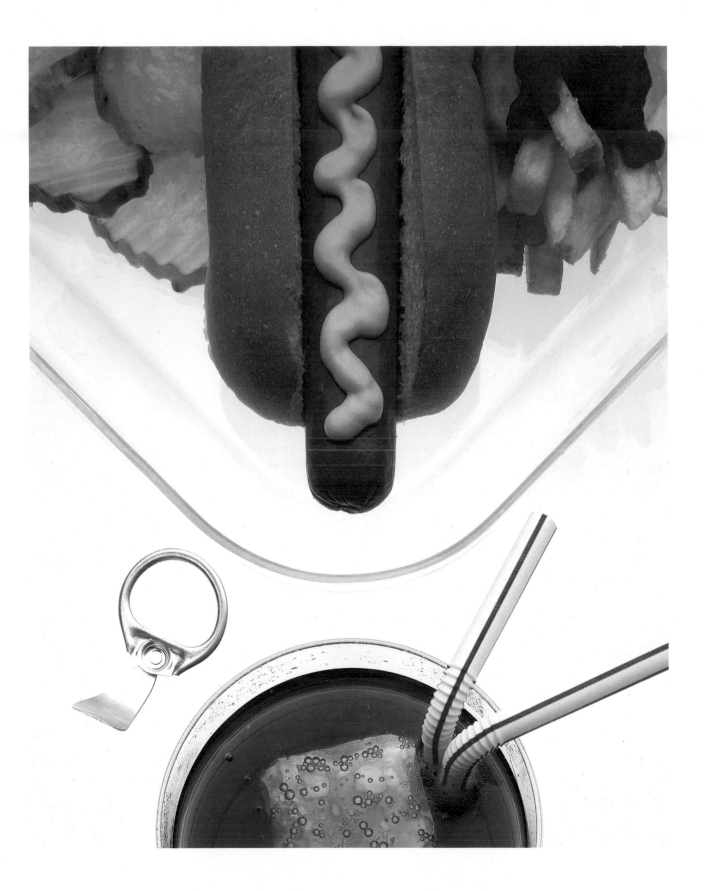

THE INTRIGUE OF A STORY TELLING ELEMENT

I wanted yellow to be the central color in this sample shot. I used light-deadening black velvet and bright white eggs for contrast, and added a story-telling element by taking one egg from the row and cracking it into the plate. I went for an amusing, thought-provoking approach to design and graphics.

I placed a square, clear-plastic plate with an indentation meant for a drinking glass on the black velvet. The velvet had a slight nap, which kept the eggs in line. The handle of the fork was painted to match the color of

the yolk, and the cracked shell was positioned to create a sense of imbalance in an otherwise symmetrical composition.

To make the photo work visually, the yolk had to be positioned dead center, but a raw yolk is extremely difficult to manipulate, and it kept breaking. I worked on the shot until two o'clock in the morning, and finally quit for the night in disgust. When I returned the next day, the yolk had

shriveled up, but was as hard as a rock and could be easily moved within the albumen without breaking. I coated the yolk with glycerine and that filled it out so it looked fresh again. Sometimes rest is better than persistence.

A single medium top light modulated the reflections on the plate and created hard reflections on the yolk and chrome of the fork. I used a wide-angle lens to create a bit of foreshortening, which gives the fork handle in the foreground more prominence in relation to the eggs.

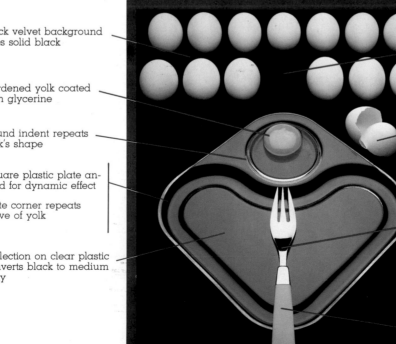

Black velvet background goes solid black

Hardened yolk coated with glycerine

Round indent repeats yolk's shape

Square plastic plate angled for dynamic effect

Plate corner repeats curve of yolk

Reflection on clear plastic converts black to medium gray

Unbroken eggs with one missing tell story

Broken shell creates off-center interest and tells story

Fork leads eye to the yolk

Fork accentuates central design arrangement

Fork's curve repeats plate corners, yolk, and egg

Fork handle matches color of yolk

Fork handle made larger by wide-angle foreshortening

Fork goes off edge, anchoring image

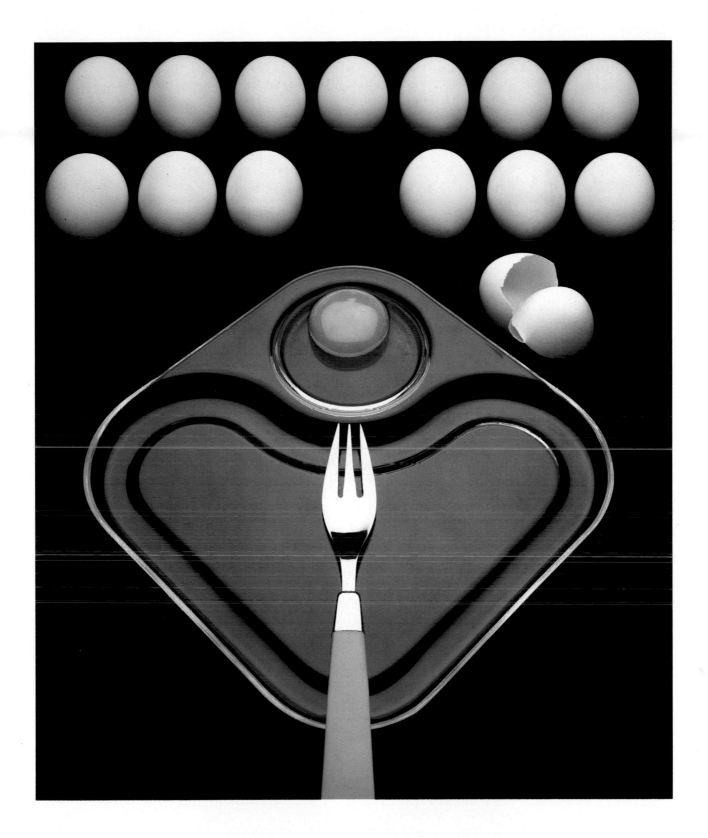

A CROISSANT JUXTAPOSED WITH A REFLECTION

This photograph, which was shot for my portfolio, shows the basic principles of design that I frequently use in my still lifes. I like the subject to occupy about two-thirds of the image, using the other elements to carefully balance the subject in relation to the frame.

A home economist provided a croissant formed in a perfectly even crescent and baked to just the right golden brown. I chose a shiny black textured show card for the background. A mixture of butter and flour was swirled from a pastry tube and then carefully set on the plate. I chose a black-and-white checkered napkin that, when folded, would

thrust toward the croissant from the base of the set. The napkin and knife also serve the important purpose of anchoring the image to one edge of the frame, so the image does not appear to be floating in mid-air.

Size relationships are crucial in providing a balance to the still life. Notice here the very subtle order in the alignment of the croissant, butter swirl, and napkin pattern. Had the checkered pattern of the napkin been larger than the size of the butter, it would have been overpowering, causing the butter to lose importance and

in turn take away from the croissant as the main subject. The uneven shape of the butter knife adds an asymmetrical element to the composition, breaking up the rigid line of balance.

One light, positioned high above the croissant, created the highlights. A black mask was cut into a shape that allowed light to hit the plate and knife, while shadowing the foreground and turning it into a matte black that contrasts with the shiny surface of the card at the top. I achieved the boomerang effect on the curved edges of the plate simply by moving the light around. I also used a front fill card to brighten up the croissant.

Black show card provides slight background texture

Reflection in top area contrasts with matte block below

Reflection reveals texture of card

Squarish plate contrasts subtly with curved shape of subject

Reflection of plate's rim created by lightening area

Plate's curve creates boomerang-like highlight that frames and echoes subject's shape

Knife and napkin point toward subject

Butter knife's lopsided blade breaks up rigid symmetry

Napkin and knife go off edge, anchoring image

Specially made croissant is perfectly even and baked to golden hue

Croissant's color and position make it central subject

Croissant's front edge lightened by fill card

Swirl of butter and flour mixture made with pastry tube

Background darkened to matte black by specially shaped mask in front of light

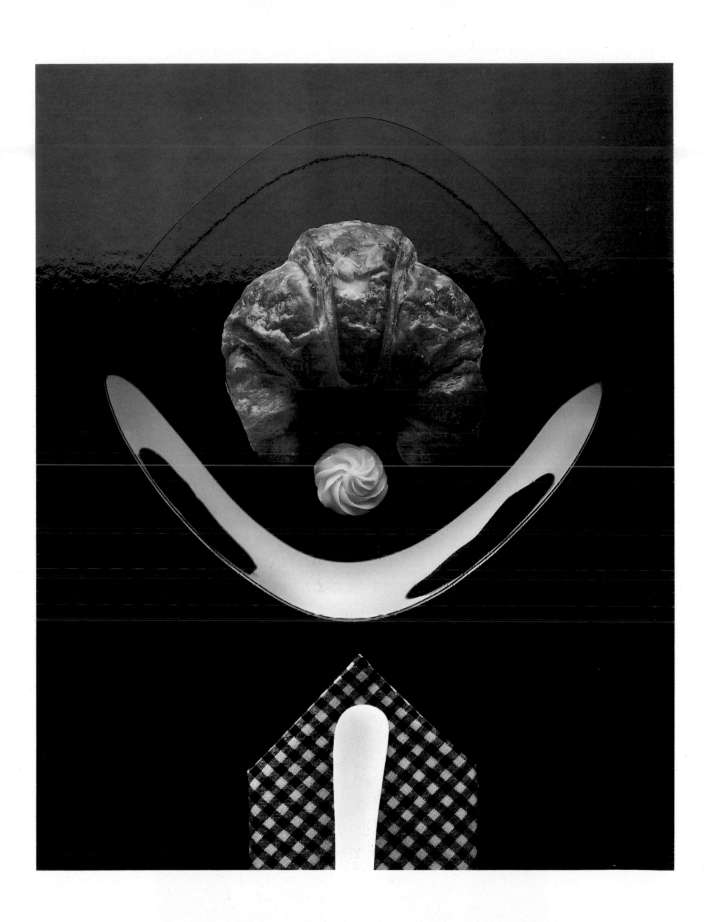

GLOWING LIGHT AS A DESIGN ELEMENT

When a frame company asked me to make this photograph for them, I immediately associated frames with painters. I asked for their color spectrum in frames, and constructed this chevron shape to accentuate the variety and intensity of their hues.

First I had my stylist locate a gallon paint can and a model maker sawed off its bottom. He then glued a disk the size of the can onto the bottom so that the container was about 1½-inches deep. The rims and handle were polished and the can was filled with black paint. Normally I would let the paint sit overnight to let the bubbles settle, but in this case I thought they would give the picture more character.

I set the can on a piece of frosted white Plexiglas so that I could achieve the blue glow around the can and tip of the brush. A light was placed above it, and another light, gelled

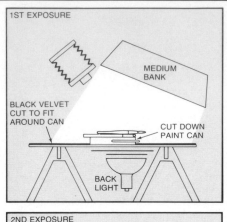

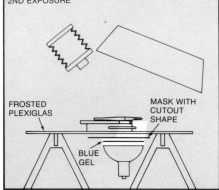

blue to match the top frame, was placed beneath. I shot the foreground first and the background glow second so that the lighting of each section wouldn't affect or alter the other. For the foreground shot, I covered the Plexiglas with black velvet that was cut to fit around the can. Then I removed the velvet and masked the blue light with a black card with a hole cut out in the shape of the can and brush.

The overhead light provided an appealing highlight along the length of the brush. I wanted the highlight to travel to the border of the picture since the brush extended all the way to the edge. I carefully adjusted the angle of the camera to accommodate the angle of the light—this determined the amount of reflection in the paint, as well as the length of the white highlight.

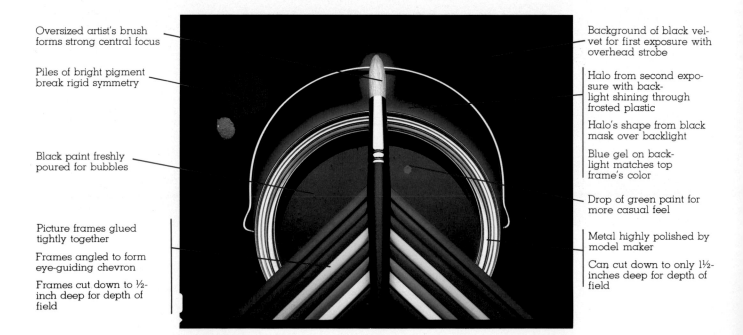

Oversized artist's brush forms strong central focus

Piles of bright pigment break rigid symmetry

Black paint freshly poured for bubbles

Picture frames glued tightly together

Frames angled to form eye-guiding chevron

Frames cut down to ½-inch deep for depth of field

Background of black velvet for first exposure with overhead strobe

Halo from second exposure with back-light shining through frosted plastic

Halo's shape from black mask over backlight

Blue gel on back-light matches top frame's color

Drop of green paint for more casual feel

Metal highly polished by model maker

Can cut down to only 1½-inches deep for depth of field

A SUBJECT'S SHAPE ECHOED BY A LIGHT

I made this shot of a Diane Von Furstenberg fragrance for my portfolio and decided to use smoke to heighten the olfactory sense suggested by the perfume. Because it was a personal picture, I didn't hesitate to alter the appearance of the bottle; I sprayed it with a matte finish to increase the smokey feeling. The smoke was provided by a machine that heats oil just to the point where it starts to smoke and then blows the smoke out through a hose. I was also inspired by the bottle's shape to make the over-all composition triangular, with the chrome ball adding a touch of interest.

The most complicated aspect of this photograph was the proper placement of four light sources. One light was gelled purple and placed behind the black blinds. I also used a white light above the set as the main light. This creates a highlight across the tops of the two black pipes under the bottle and also casts thin white highlights across the tops of the blinds. I adjusted the opening of the blinds so that the highlights would become smaller as they traveled upward and as the background light coming through grew progressively greater. At the bottom of the set I used a long, narrow strip light, gelled purple

to give the base of the pipes a purple glow, and to reflect a purple crescent on the ball bearing off to the right. I lit the smoke with a white strip light placed between the blinds and the foreground. Lighting the smoke prevented a muddy appearance and also cast additional highlights on the chrome ball. I shot the front lights and back light separately, so this is a double exposure. I dropped a piece of black velvet behind the blinds when I exposed the foreground elements. Then I took away the velvet and exposed the back light, which was slightly angled and masked to create the triangular shape.

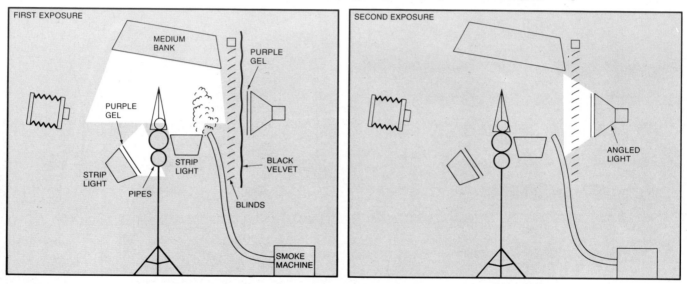

FIRST EXPOSURE

MEDIUM BANK

PURPLE GEL

PURPLE GEL

STRIP LIGHT

STRIP LIGHT

PIPES

BLACK VELVET

BLINDS

SMOKE MACHINE

SECOND EXPOSURE

ANGLED LIGHT

Thin black venetian blinds create strong linear background

Bottle dulled with matting spray

Spraying gives bottle frosted color that echoes smoke

Smoke from oil-burning machine adds olfactory note

Smoke frozen by short flash duration

Smoke lighted from below

Two plastic pipes create strong horizontal supporting objects

Strobe head angled behind blind repeats bottle's shape

Blinds angled so that backlight lines get progressively thinner and highlights get thicker

Backlight recorded during second exposure

Large ball bearing balances bottle and adds contrasting shape

Bottle, bearing, and smoke recorded during first exposure

Highlight from main strobe overhead

Highlight from filtered strobe below

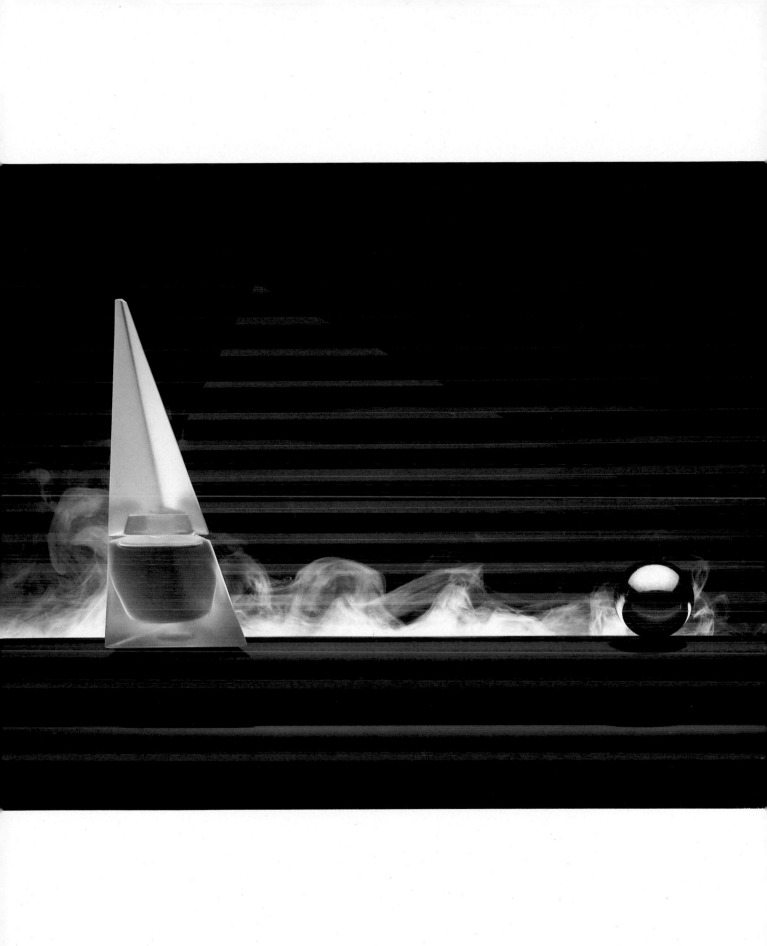

Part Two
DISPLAYING A PRODUCT

Shooting products may seem simple enough, but it's really an exercise in trickery. With so many surfaces, each reflecting or absorbing light in different ways, creating a set can become an overwhelming orchestration. Just imagine—in one picture you might have chrome reflecting light very strongly, and wood soaking it up like a sponge. You don't want your picture to give the impression that light is coming from 50 different directions or it will get very busy, yet you want to light each object to its best advantage. I always try to keep things simple; the viewer must focus on the product you're trying to sell, and the lighting should be determined according to the way it will best present that product.

Lots of things are learned by experience and shooting products is no exception. Along the way you find out that when you light silver with white light you get white, not silver. You learn that chrome will appear black unless you use a main light and a big dull silver card to give a modeled, secondary highlight. You learn that you need to vary the intensity of light to make an interesting image and that two highlights of equal intensity will accomplish very little. You may discover that Plexiglas often has a lot of green or cyan in it, and that must be filtered out. Or a gray that is cool to the camera will be warmer to the eye so the film should be filtered to warm it up. All these little tips come in handy, but the main idea to keep in mind is

that the traditional, clean, simple lighting setup with a main light and a bit of fill is a method that creates a wonderful modeling of shapes. A picture that is over- or under-lit is a disaster, and your product will suffer because of it.

It may seem strange to make a hero out of a hot-dog or a pair of shoes but that's what product shots are all about. The still life photographer shouldn't get so caught up in creating an interesting set or designing an intricate composition that he forgets who—or in this case—what the star of his photo really is. So when I compose a picture I first try to consider the best way to make the product stand out. Sometimes this is accomplished by making the product the strongest, or the only colored object in the picture. If the product is placed on a big black page and shot very small, the eye goes right to it. Or it can fill the whole frame. It can be positioned in the dominant foreground and shot with a wide-angle lens so that even if it's surrounded by other objects it's still the most important element. There are plenty of solutions to each problem—the trick is finding the right one.

Since the purpose of advertising is to sell a product you have to remember that no matter how great your picture is, it's not doing the job if it doesn't present the product in a clean, interesting manner. The picture should make you want to know more about the product. In fact, it should make you want to run right out and buy it.

A ROSE TO SOFTEN A COOL, HARD SUBJECT

This Gucci telephone was scheduled to appear in *Architectural Digest,* so I decided to create a set incorporating materials that an architect might use in the construction of a building. Sometimes the best photographic concepts arise from carefully assessing the place where the picture will be viewed.

I picked electrical conduit piping for the background because they matched the phone and also because I liked the linear pattern they created. I painted the pipes silver and then placed them next to each other. In some places I exposed the seam where the two sections of each pipe joined in order to break up the monotony of seeing one

cylinder after another. When I placed the phone on the piping, I realized that something was needed to soften the shot and, at the same time, to add color, because the picture was too monochromatic. I chose a red rose because of its circular, symmetrical fragility and its brilliant color. I also felt the picture was too monochromatic. I spritzed the rose with glycerine and water, and cut off its stem, selecting some perfectly shaped leaves to place underneath for bal-

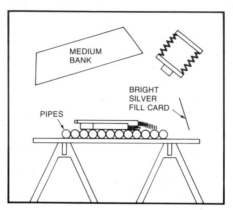

ance. The rose added just enough color and contrast to complement the phone without detracting from it, whereas another type of flower—an orchid, for instance—would have been unruly and asymmetrical. The rose also played nicely against the tiny red dot on the phone.

I used one bank light overhead in the rear of the set, positioned so that the light would fall off as it moved down the image. A bright silver fill card created a highlight on the front edge of the telephone, but I was careful to maintain the shadows in the front of the phone. The fill card also opened up the cord so you can see the detail.

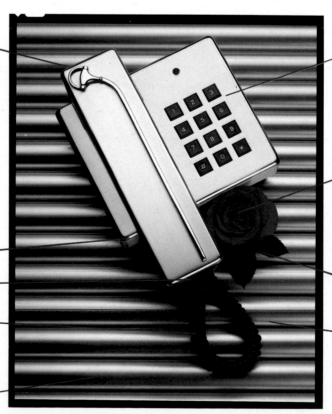

Background of conduit pipe creates strong linear pattern

Pipe painted silver to echo phone's color

Highlight on phone edge from bright silver fill card

Fill controlled to retain shadow area

Fill card also puts highlight on black card, revealing detail

Shadow size on pipes gradually increases as light falls off at bottom

Phone's large size makes it subject even though rose is brighter

Phone angled to stand out against pipe's horizontal lines

Rose adds bright, shocking color to silver composition and echoes dot on phone

Rose placed face up to create strong circular pattern against lines

Rose softens other hard elements in composition

Different-sized leaves for asymmetrical balance

Seam exposed in some pipe to break monotony

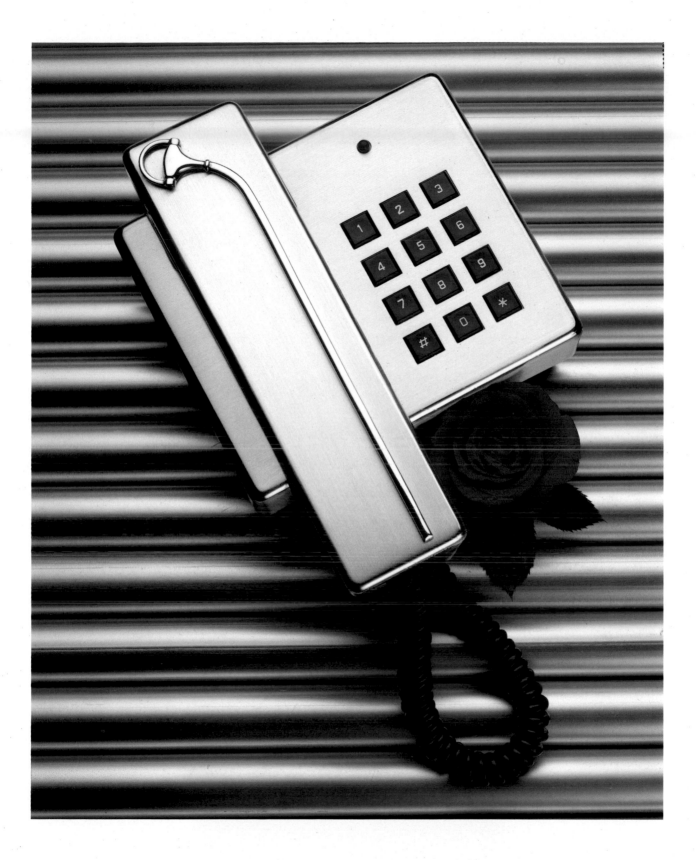

THE PROMINENCE OF A BRIGHT SUBJECT

I wanted a strong color theme in this photograph of a Gucci shoe, so I made red the dominant color. Since the shoe was matte, I needed a shiny material to add contrast without becoming overpowering. Black ceramic tile provided the perfect solution.

I painted the brown leather inside the shoe red because I wanted a uniform color. If I had lowered the camera angle so I wouldn't see the inside of the shoe, the sole would have been visible. To create a strong horizontal line, I placed the shoe on a piece of brushed aluminum corner molding which I ran along the top of the tile. I hung a piece of black velvet in the background because I didn't want any light modulation to conflict with the line of chrome. To make the set a little more intriguing, I decided to remove the shoelace from the shoe and drape it around a chrome knob, which was affixed to the tile with some Fun Tak so it could be moved easily to accommodate changes in the composition. The placement of the shoelace not only adds interest to the picture,

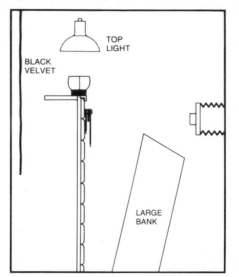

but also helps to fill the negative space with a related object.

The shoe was top lit, but the most important light source was a large, 4 × 6-foot bank placed in front of the tile. Since there was no distinct foreground or background, the shot would have been very flat without the depth provided by the reflections in the tile. The reflections caused the tile to appear about 80-percent black, while the matte-black grout stayed at 100 percent, creating a nice grid. I shot the picture from a distance with a long lens so the light could be placed in front of my camera.

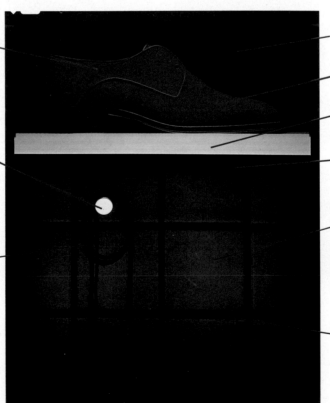

Bright color makes shoe main object

Inside of shoe painted red to unify subject

Chrome knob's color echoes aluminum trim

Knob affixed with hot glue for maneuverability

Out-of-shoe lace becomes story-telling element

Shoelace adds interest and breaks formality

Casual circular form contrasts with grid

Black velvet background creates area of solid black

Curved shape set off by rectilinear composition

Brushed aluminum trim forms strong horizontal supporting shoe

Black area with no reflection makes aluminum trim stand out

Black ceramic tile contrasts with matte shoe

Reflection on tile from large front light

Tile lightened to 80% black by reflection

Non-reflective grout creates solid-black grid

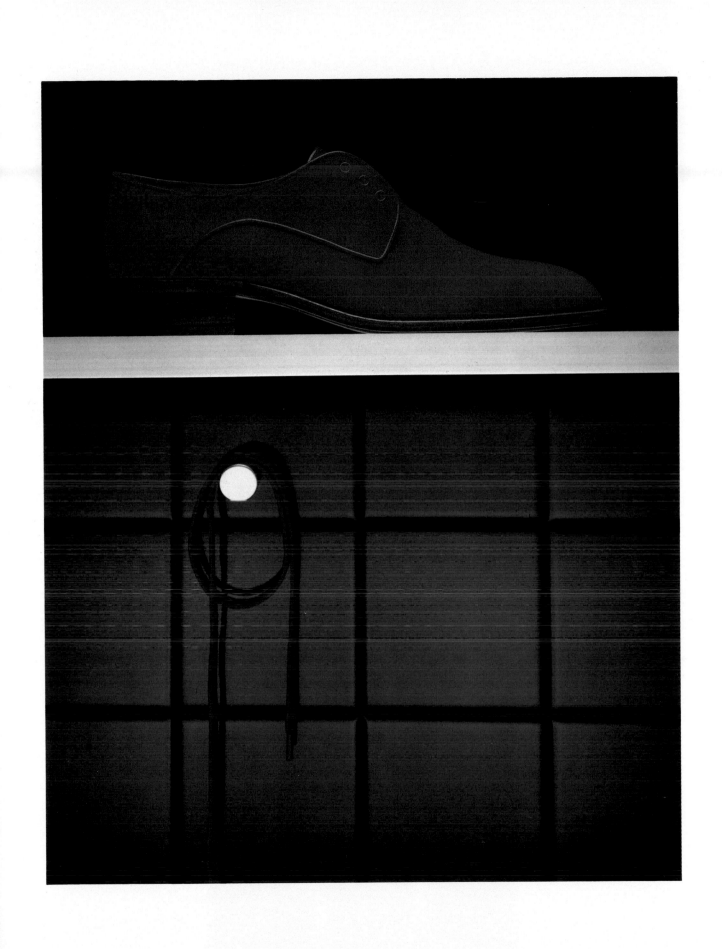

A SANDAL WITH A ROMAN AIR

This shoe, which I also shot for Gucci, seemed almost like a Roman centurian's mask to me, and I wanted to treat it in an exaggerated manner so that it would appear almost as a piece of armor. I hoped to create a very sculptured, modeled image.

I placed the shoe, with the strap carefully arranged in a symmetrical arc, on a sheet of black Plexiglas covered with small, flat black beads that are pieces from a board game. I thought they would suggest a rather volcanic surface, reminiscent of Pom-

peii. The Plexiglas reflected as an 80- or 90-percent black, but the beads and their shadows read almost 100-percent black, creating a very subtle background mosaic. I covered the inside of the shoe with black velvet, which maintained the contrast against the gold and made the shoe appear hollow, adding to the sculptured quality. The velvet was cut so that

the gold that shows along the edges is about the same width as the straps.

I shot almost straight down with a 300mm lens and used one top light, which created the reflection in the Plexiglas. I didn't use a fill because that would have lightened the sides of the shoe, lessening the drama. The top light flattened the shoe and emphasized the sense of mass and substance. This was a different approach to shooting an open-toed sandal, a shoe one usually thinks of as very frivolous and unsubstantial.

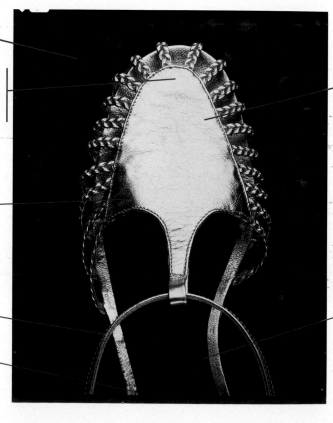

Background of black Plexiglas covered with flat black beads

Shoe's toe centered for prominence

Wad of tissue lifts toe top slightly

Natural fall off of light gives subject a sculptural quality

Light subtly drops off at bottom of image

Heel and strap go off edge, anchoring image

Highlight from overhead light

Black velvet cut to cover inside of sole, simplifying subject

Velvet insert keeps sole's edge narrow to echo strap

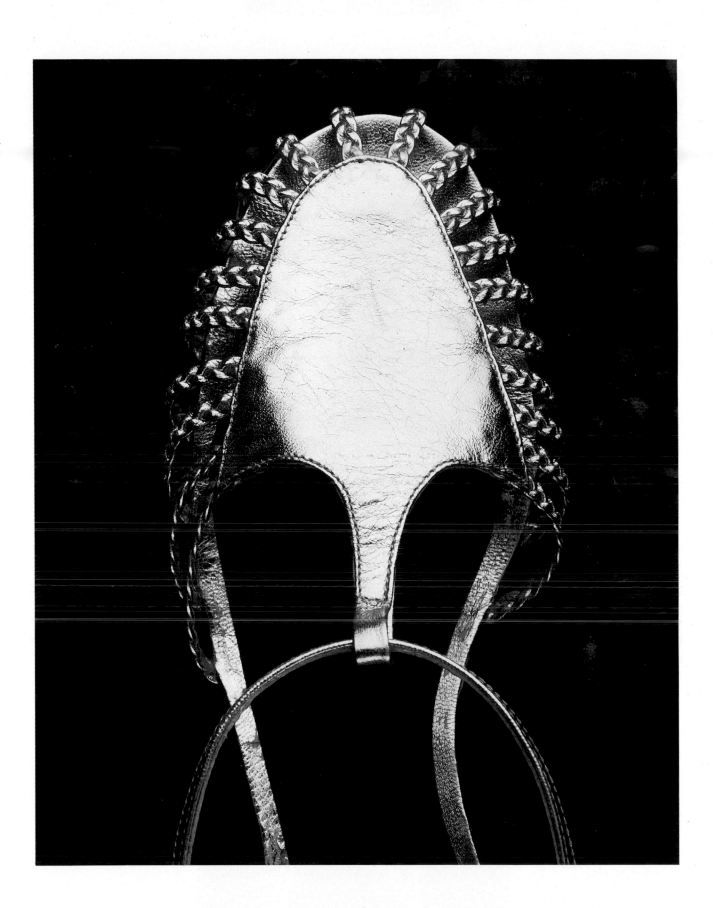

PENS THAT STAND OUT FROM THE ORDINARY

Gucci gave me carte blanche for all his products, and I decided on the theme of "Gucci stands out in the crowd." I wanted the Gucci pens to dominate in color and intensity so I contrasted them with a background of common black felt-tip pens.

First I arranged the markers in diagonal rows on a sheet of black Plexiglas. Then I placed the gold and silver Gucci pens on top of the felt pens. To break up the balance of the composition and make it more interesting I took the cap off one of the two silver pens and positioned it at an angle.

I used one light above the set, but because I wanted to add dimension to the pens, I used fill cards positioned on stands to create a second highlight. A dull silver card was placed on

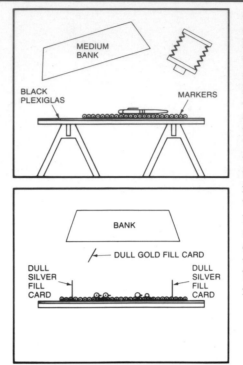

either side of the silver pens, low enough so their reflections wouldn't hit the gold pen. A third card, this time a dull gold, was placed at a slightly higher level to fill the gold pen. I purposely chose to use dull cards to provide highlights that gradually grew in intensity, creating variations of light from subtle to bright. White or shiny cards would have provided highlights of equal intensity to the main light, thus creating a less interesting modulation of light. I used very narrow reflectors, about ¼-inch wide, to keep the reflections from spreading. The Gucci pens sparkled in elegant contrast to the subdued silvers in the background and the matte black shadows between the common markers.

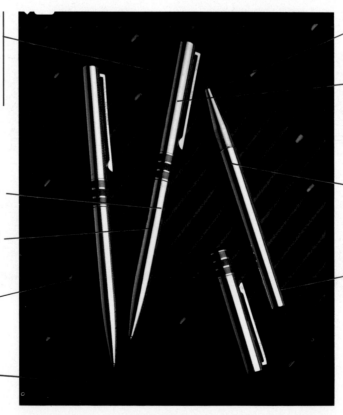

Black felt-tipped markers in diagonal rows

Markers matte finish gives subdued highlight

Deep shadows give dimension to markers

Main highlight from overhead light

Lesser highlight from dull silver fill card

Background uniformity broken by irregular position of marker tips

Light fall off reduces background's regularity

Black Plexiglas under markers

Gold pen in central position flanked by silver pens

Pens arranged at angle to stand out against diagonal markers

Second silver pen taken apart to break up composition

Marker tips hidden by pens

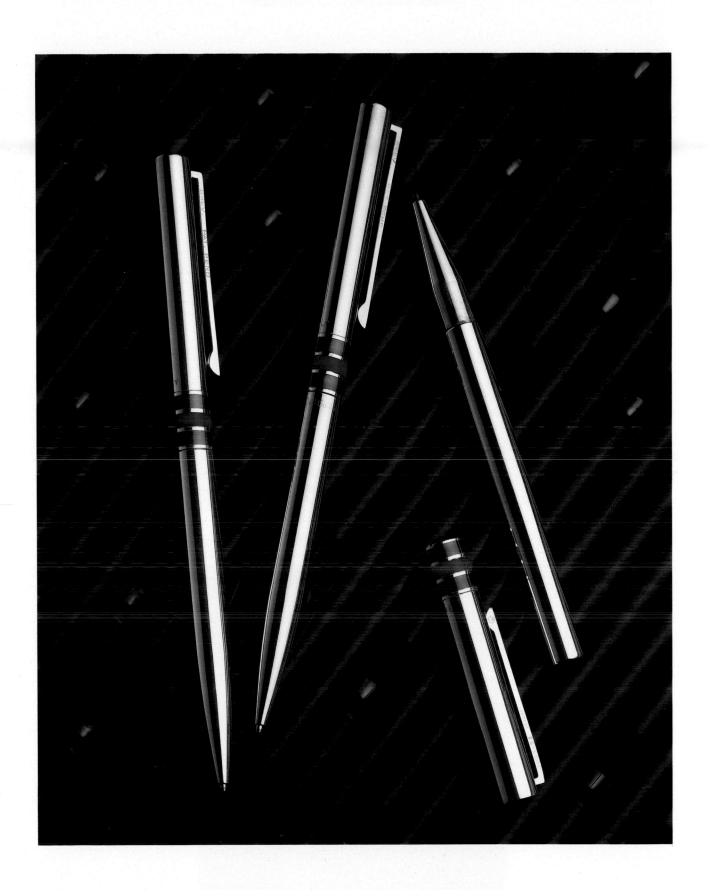

A MONUMENTAL BOX OF L'OREAL

I suppose everyone has to shoot a cardboard box sometime in his or her career—the trick is coming up with an interesting way of presenting a rather mundane object. Fortunately, this L'Oreal box was attractively designed, with large black type and a visually appealing color gradation from magenta to gray. It also has this enormous eye that immediately grabs your attention.

I decided to complement the color gradations by using magenta in the background, and gradating from gray to black. I placed the box on a piece of shiny black Plexiglas, which allowed for a strong reflection, and I arranged the set so that there would be a strong glowing horizon line across the back. I centered the box and tilted it slightly to make it more dynamic and to provide a sense of dimension.

I shot this photograph with an extreme wide-angle lens and positioned the camera quite a bit lower than usual, both to ensure a dramatic reflection and to create the illusion that the box was of monumental importance. I wanted to give the impression of the box as a monolith and the combination of a wide-angle lens and a low angle creates very dynamic lines of perspective that taper off very quickly. I used a sidelight on the right and decided not to fill the left side because I wanted to maintain a strong black rectangular shape. It also let me hide the type on that side of the box.

A strip light with a magenta gel was placed behind a sheet of frosted Plexiglas in the background to provide the magenta horizon line. By using complementary color themes and a basic, clean design, I was able to use an ordinary shape in a way that suggested an exciting, vital product.

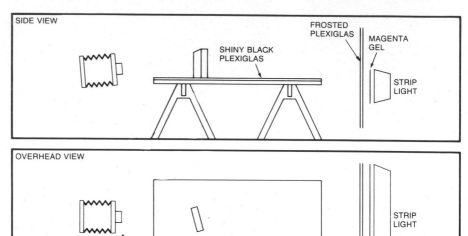

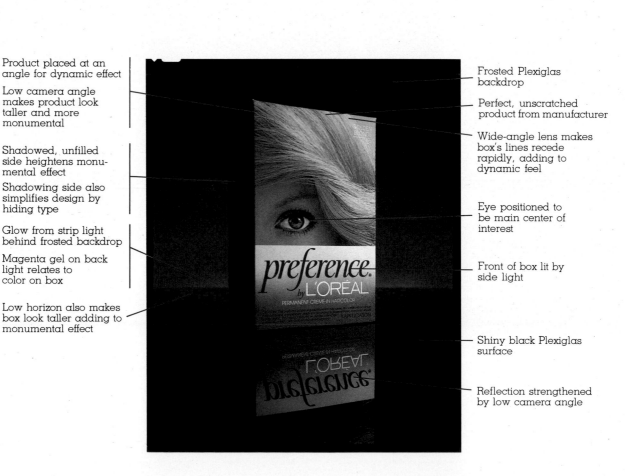

Product placed at an angle for dynamic effect

Low camera angle makes product look taller and more monumental

Shadowed, unfilled side heightens monumental effect

Shadowing side also simplifies design by hiding type

Glow from strip light behind frosted backdrop

Magenta gel on back light relates to color on box

Low horizon also makes box look taller adding to monumental effect

Frosted Plexiglas backdrop

Perfect, unscratched product from manufacturer

Wide-angle lens makes box's lines recede rapidly, adding to dynamic feel

Eye positioned to be main center of interest

Front of box lit by side light

Shiny black Plexiglas surface

Reflection strengthened by low camera angle

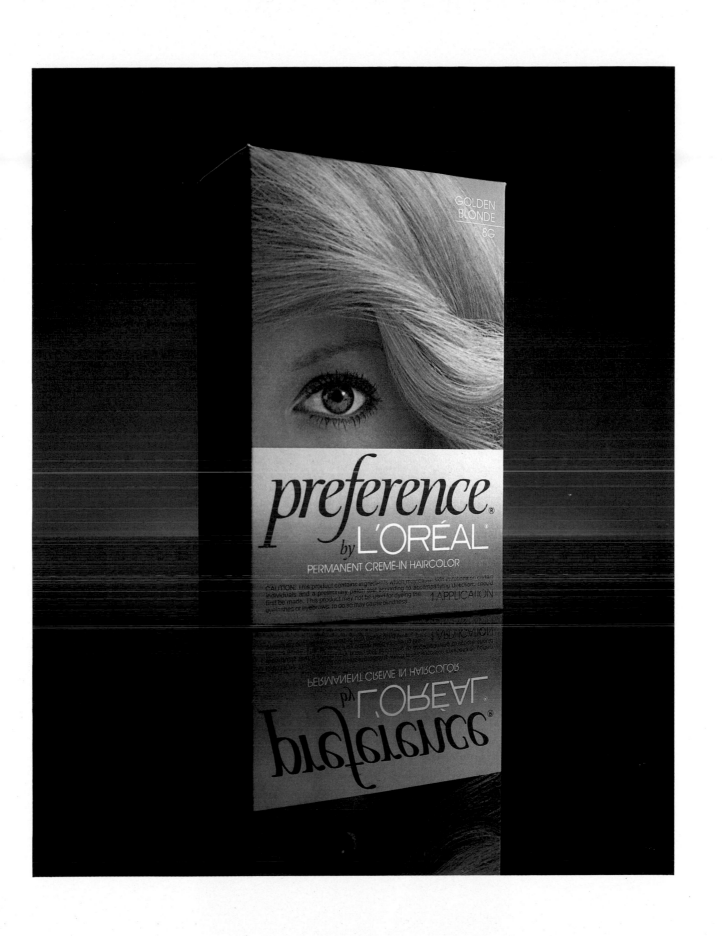

A SUBJECT SHOT HEAD-DOWN FOR DYNAMIC EFFECT

For Calandre perfume, I needed a dramatic photograph that would describe the product and would also be consistent with the packaging. To match the mood of the perfume, I knew I would have to stray a bit away from my usual style. I created a dynamic sense of perspective by photographing the bottle flat on its back with its top toward the camera. A side benefit of that position was that it created an intriguing air pocket in the liquid. When the photograph was run, the chrome was simply turned upside down, as shown on the opposite page. I placed the bottle on black velvet, but alone it was not interesting enough to sustain the im-

age. So I took two chrome pipes that I had in the studio and placed them on either side of the bottle. I keep all kinds of objects around the studio to use as props, and it's amazing how often they inspire a spur-of-the-moment idea that blossoms into a successful photograph. The pipes caught the same fragmented reflections as the chrome on the bottle, since both shapes were cylindrical and reflected the light identically. The long, white highlights created a sort of mirrored effect. These are the

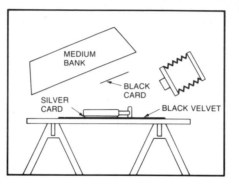

kinds of serendipitous surprises that happen in pictures; if you envisioned them beforehand you'd have to spend hours working them out. Perhaps you never would. I always try to let chance play its part in the creation of an image.

A top light created the fragmented highlights on the chrome, and turned a second cap, placed standing up next to the bottle into a reflected crescent. I also put a silver card under the perfume bottle to brighten the liquid with reflected light. Black cards cut off light in certain areas and enhanced the highlights and reflections in the chrome, which can otherwise become very flat when photographed.

Shiny chrome pipes flank subject, echoing its chrome frame

Pipes angled to create dark, dynamic triangles at sides of bottle

Silver card under bottle lights contents

Interesting bubble created by laying bottle on its back

Chrome pipe repeats reflection on bottle top

Reflections shaped by black cards in front of light

Light falls off at what will be the image's top

Black velvet background for solid black

Light is brightest at what will be the image's bottom

Bottle angled to heighten dynamic effect of unusual perspective

Top toward camera becomes dramatically wider than bottom

Crescent highlight on second cap

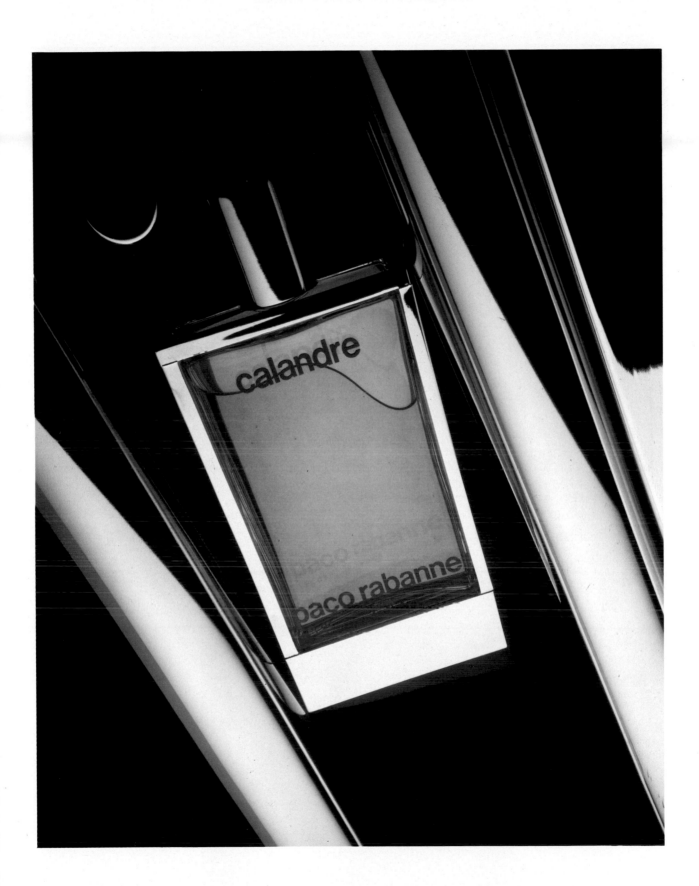

PAINT DRIPPINGS TO SUGGEST A MULTICOLORED ARRAY

In this photograph of Rooster ties, made for Bloomingdales, I wanted to make a color statement. From a selection of about 100 ties in a variety of colors, I chose to feature only three, using strong colors that worked together harmoniously.

To suggest the many possibilities of color, I used a silver paint can covered with a multicolored array of paint drippings. I thought that the numerous paint hues would imply that the ties came in many different shades. To make the can look like it had been filled to the rim so that the paint ran down the sides, I dribbled fast-drying, acrylic paint along the edges. I used colors that either repeated the color of the ties or went well with the ties.

The photograph was lit with a main light on the left side and a fill card on the right. I chose sidelighting because it helps reveal the texture of the ties. I backlit the set with a small round head aimed through a sheet of Plexiglas to create the slight glow of light around the edges of the can. This halation effect created a sense of depth and livened up the picture.

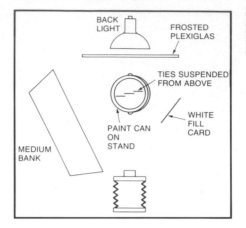

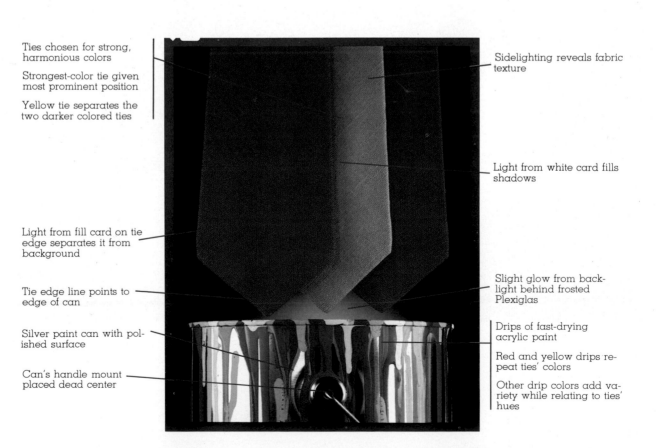

Ties chosen for strong, harmonious colors

Strongest-color tie given most prominent position

Yellow tie separates the two darker colored ties

Light from fill card on tie edge separates it from background

Tie edge line points to edge of can

Silver paint can with polished surface

Can's handle mount placed dead center

Sidelighting reveals fabric texture

Light from white card fills shadows

Slight glow from backlight behind frosted Plexiglas

Drips of fast-drying acrylic paint

Red and yellow drips repeat ties' colors

Other drip colors add variety while relating to ties' hues

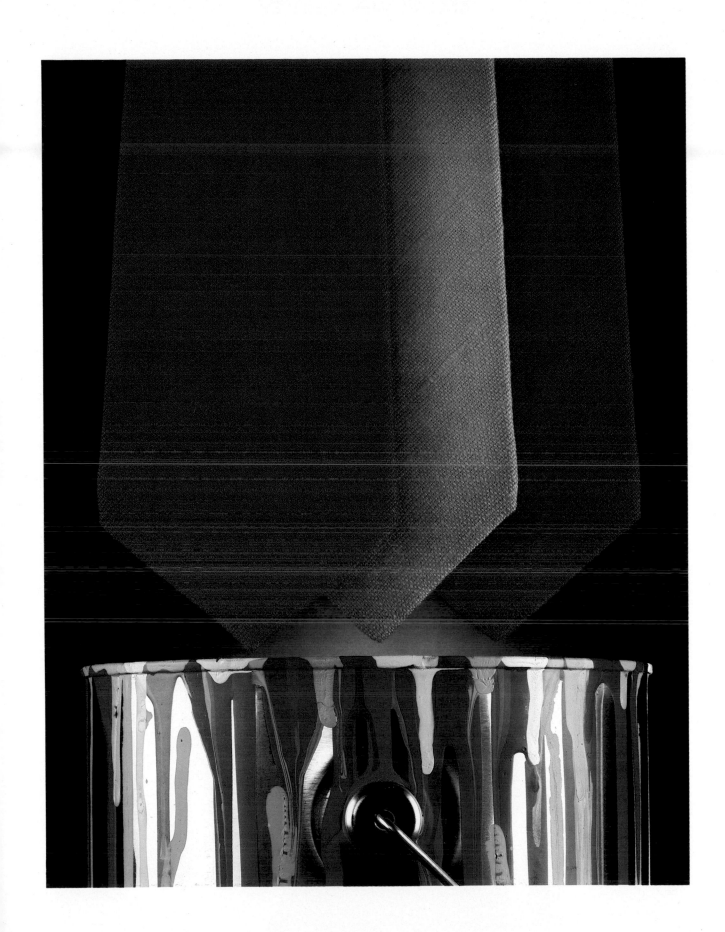

A SUGGESTION OF THE PRODUCT'S USE

For Bordon's Ink I decided to make a very flatly lit picture without any tonality, using putty knives and spatulas—things that printers use to mix ink. I wanted to present small, medium, and large shapes in an exaggerated manner so that in the image they would become larger-than-life.

I placed the spatulas on black velvet, which has a nap and, unlike Formica, will hold the shape of most liquids placed on it. I also wanted a neutral background to contrast with the colors of the ink. I used red, yellow, and blue—very vibrant colors—and placed a bit of pigment in the upper right-hand corner to break up the black space (and to provide another texture). I added a small red dot on the largest spatula because it was too open and flat. I also added small bubbles to the ink with a straw to break up the surface of color. We left the type on the handles because this is the kind of image that is very

stark, and a little type can add an element of tension.

The set was lit with a top light, without any fill. I wanted the set to go flat, so that the whole image looked almost cut out. The combination of large, level objects, the thick, pasty-looking ink, and the silver spatulas reflecting white, created a simple but dramatic design. The strong colors of the ink spoke for the purity of the product—a complicated set was unnecessary, and I felt the simplicity of this composition resulted in a very strong visual statement.

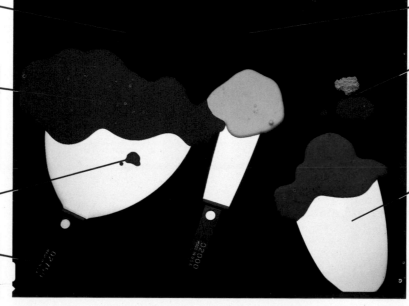

Black velvet background goes flat, solid black

Inks selected for their vibrant colors

Inks poured into interesting, undulating shapes

Velvet's nap keeps viscous ink from running

Bubbles add texture to ink

Dot of red ink added to break up space

Type on handles adds texture

Bottom half of handles removed to make spatulas lie flat

Single toplight creates overall flat effect

Powdered pigment adds unexpected texture

Silver surfaces photograph flat white

Spatulas of different sizes provide similar, but not uniform, shapes

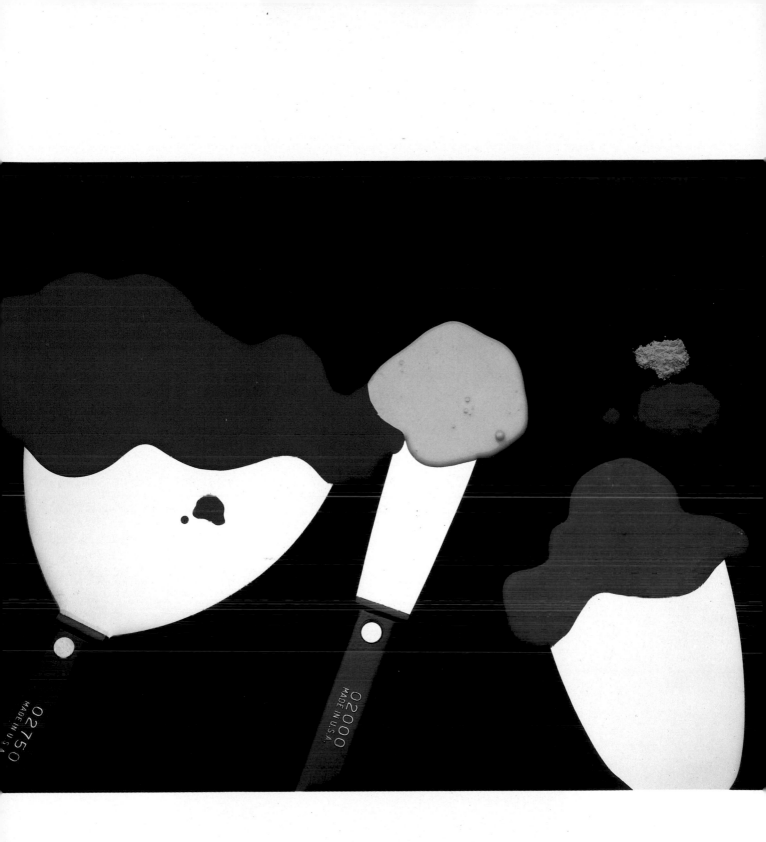

02750
MADE IN U.S.A.

02000
MADE IN U.S.A.

STILL LIFE IN A CAR TRUNK

Props and composition were important in this product shot of a General Electric CB radio that can be plugged into a lighter and used to summon help when your car breaks down on the road. The most time-consuming aspect of making this photograph was finding the right kind of car. Dealers don't like to part with cars they have in the showroom, and generally American advertisers prefer to use American cars. So I sent one of my assistants out to locate a brand new rental car—in this case it was a Mustang. I wanted a neutral gray car so that the product would possess the dominant color, and removed the trunk lid to facilitate lighting the set. The New York license plate on the car was black and orange like the radio, so I switched to a blue-and-yellow New Jersey plate to vary the colors.

I wanted the scene to dramatize a family packing a load of paraphernalia for a short vacation or weekend trip. My stylist picked out all kinds of lug-

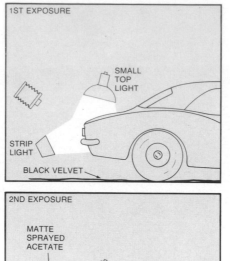

gage, picnic baskets, fishing poles, and so forth, and I arranged them in the trunk with the self-help radio in the center. Since the product comes in a black box, I wanted to place it on a lighter background, so I used the wicker picnic basket for contrast.

The shot was top lit with a small light, which provided a fall off on each side of the radio and resulted in a spotlight effect. A strip light was placed in front of the bumper, license plate, and the objects in the trunk. I sprayed parts of the car with a dull matte finish to soften the reflections. The parking lights were recorded during a second, time exposure, through a piece of acetate coated with matte spray. I only used a light coating of spray, since the foggier the acetate, the more profuse the glow. I also kept the acetate in motion during the exposure to avoid recording its uneven texture. The area below the car, where the type was to be later dropped out, was covered with black velvet.

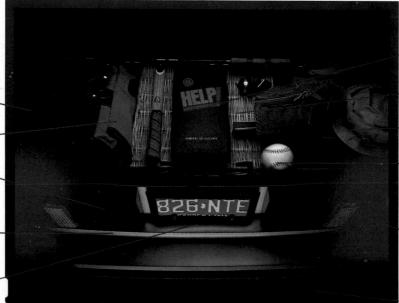

Darker objects placed toward edges

Luggage suggests a trip

Neutral gray car finish reduces color in shot

Car's chrome dulled with matting spray

License plate and bumper lit by front strip light

Subject placed center for prominence

Light-colored wicker basket sets off dark subject

Light falls off at edges of trunk

Sports gear suggest a vacation

Car lights recorded during long second exposure

Car lights fogged by moving matte-sprayed acetate over lens during second exposure

Black velvet on floor goes solid black

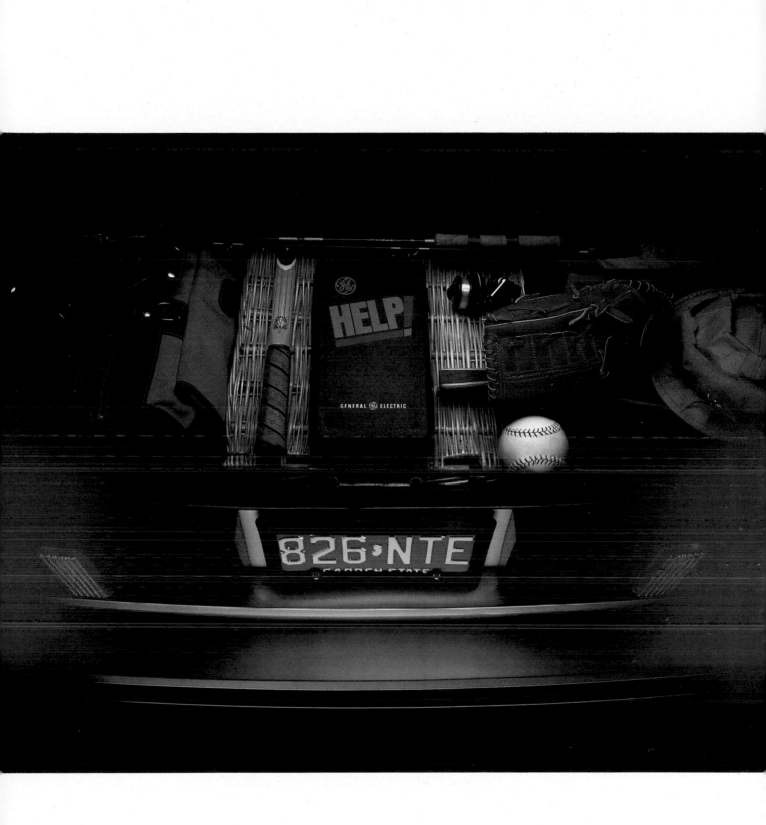

Part Three
ARRANGING A GROUPING

Often I'll be called upon to photograph a group of objects, whether they're men's ties, ladies' handbags or spring clothes. Usually, the client or magazine gives me a wide array of materials, and it's up to me to decide which items look best together and what their placement should be. When you're dealing with large groups of objects, it's easy to lose sight of your focal point, and when that happens the result is a chaotic picture that has no sense of balance or continuity. The key to making a successful group shot is to establish some rules in order to create an image that makes visual sense.

My first step is to decide upon a central theme or focus point. When I place one object on a background, often the other elements quite naturally fall into place. I prefer using some kind of dynamic shape around which the other shapes revolve. This is a simple method, but one that is dependable and logical. You can't let yourself get hooked on preconceived ideas, however. Group shots are best when you leave room for trial and error. You shouldn't be afraid to rearrange and reconstruct until you get an arrangement that really works well.

When I'm selecting the materials for a group picture I also like to consider what textures and colors work best together. If you're creating a soft, romantic sort of shot it's better, for instance, to pick materials with a paisley design rather than geometric patterns or hard stripes. Sometimes I'll put a little wrinkle in a sleeve or a collar or rumple up a bit of material to create a more organic atmosphere. If you're using a busy sort of background, you might want to use cleaner objects on top of it, and vice versa. For a double-page illustration, you also should be aware of whether the objects will fall into the gutter of the page, and arrange them accordingly.

Color plays a very important part in groupings, though it's hard to lay down any fast rules. Sometimes shades of the same hue work best; it might be nice to use gray flannel, gray pinstripes, and only a touch of color. The more color you add, the busier the image becomes. If you use three objects of the same color, for instance, you really get only one photo. But when you use three different colored objects you're actually creating three separate little photos within the larger frame. Sometimes it's best to arrange the colors in an orderly fashion—reds with reds, blues with blues. Other times I like to jumble things up a bit. But you should always experiment with different versions before you decide which works best because the interplay of shapes, textures, and colors may surprise you, and there's always an element of serendipity when you allow yourself room to play with the objects on a set. Because of the many possibilities and the time limit involved (usually the photographer is expected to produce this kind of image in a single day) arranging the elements for a group shot can be an interesting challenge in skill and imagination.

AN ARRANGEMENT WITH A READING AND WRITING THEME

This photograph is part of an ongoing series that I shoot for *Gentleman's Quarterly* magazine. At the outset of the project, the editors would bring me 50 or more objects to fit into a single photo. I convinced them to narrow down the accessories so we could shoot cleaner, more graphic pictures, with all of the elements shown larger within the frame. Scale is very important to the success of an image. It's wonderful to see an object that's generally really small blown up quite large, or something quite large reduced. In this picture, I was dealing with fairly small objects that would be used to fill a magazine page. I had only a short amount of time for the shot since these magazine assignments are often done on a rush schedule—"Here are the objects, now shoot the picture." The smaller photograph, shown here, uses the same type of background with different elements.

The theme for the shot was writing and reading so I chose pens, eyeglasses, and a book as the central elements and placed them on the gray Ultrasuede background. I wanted the colors to be warm except for a constant background, which would appear in other shots in the actual magazine.

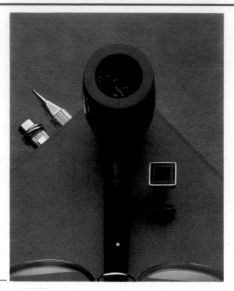

The book was positioned to thrust toward the top of the page, creating a triangle and providing a point of tension. I varied the lengths of the pens, which had a fluting that added a busy quality. This contrasted with the flat texture of the calculator. I chose the eyeglasses to match the color of the book, and also to contrast their round shape to the sharp angles of the book and calculator. The cuff links picked up on the rectangular shapes, as did the keys of the calculator, which was silver to match the tone of the background. This variety of shapes, textures, and earthtones made the image an exciting study of juxtaposition and contrast.

I lit the picture with a large 4 × 6-foot bank light positioned to hit the pens directly. Because of the convex curve in the eyeglasses, I had to allow for reflections, and I needed a very large light source to get a long highlight on the glass area. With a smaller bank, you would get small, angular reflections. In some instances it is better to remove the glass from the frames, but in this case, the highlights were a plus. Unexpectedly, the light fell off naturally in the left-hand corner, creating a pleasing effect.

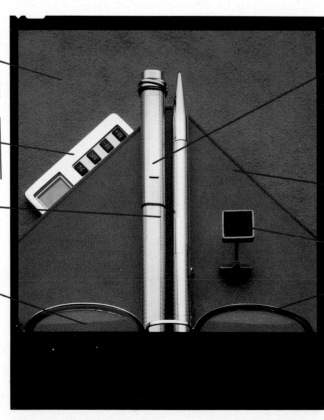

Gray Ultrasuede provides neutral but textured background

Negative space left for drop-in type

Only part of busy calculator shows

Cool tones of background and calculator balance warm browns

Warm colors link glasses, book, cuff link, and gold pen

Reflection on glasses kept small and subtle

Bright pens given central position

Large, squarish gold pen played off against smaller, cylindrical silver pen

Fluting on pens adds subtle detail to break up flat surface

Book angled to create central upward thrusting triangle

Dark square cuff link echoes calculator's buttons

Round glasses contrast with other linear shapes

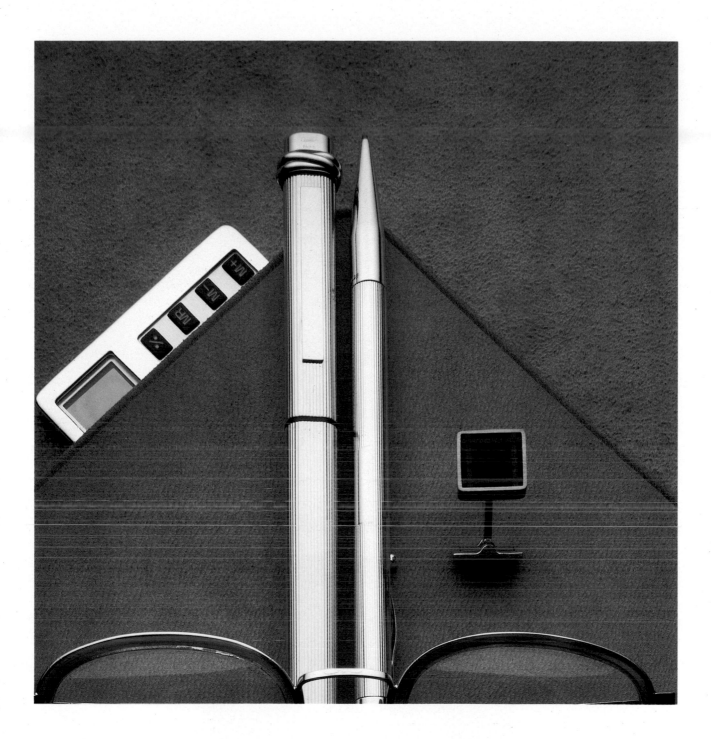

A GROUPING OF CONTRASTING SHAPES

This is another shot done for *Gentleman's Quarterly* magazine, this time illustrating an article on men's accessories. I'm allowed the freedom to pick the elements that will be included in the *GQ* photographs, and in this case I decided to experiment with a black-and-silver design scheme. I chose the silver cigarette lighter, a black-faced metal watch, a black snakeskin wallet, and sterling silver cuff links, and arranged them in this very simple design, with the cuff links angled just off to one side for balance. I used the black snakeskin wallet as part of the background and arranged the other elements on top of it, with

the very graphic cigarette lighter in the center. For the remainder of the background, I used a neutral gray Ultrasuede, which went well with the photographs of clothing that I knew would appear on the opposite page of the magazine. This picture was intended to be cool, and the choice of colors of the objects was essential— black, silver, and gray.

One top light, positioned in the back, lit the set. In order to prevent reflections from bouncing off the crystal of the watch, I positioned a small

black disk, the same size as the watch's face, over the light. This blocked the reflection, yet allowed sufficient light to illuminate the picture and to brighten the face. The lighter was angled slightly so that the disk's reflection wouldn't be seen in the chrome. The light was also positioned to create a modulation on the cuff links and to provide reflections on the lighter while maintaining the detail of the snakeskin. I shot with a 165mm wide-angle lens. I like its foreshortening and perspective qualities, and it lets you shoot very small subjects close up, so you don't end up standing on a ladder ten-feet high.

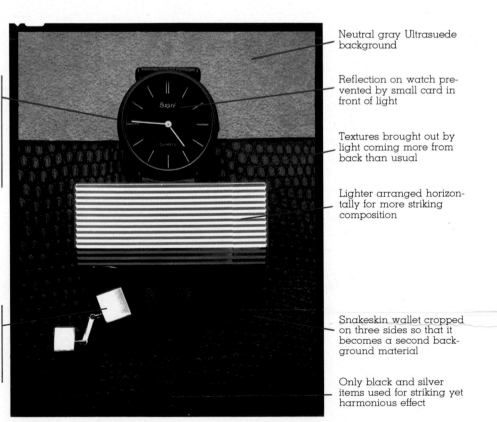

Neutral gray Ultrasuede background

Reflection on watch prevented by small card in front of light

Textures brought out by light coming more from back than usual

Lighter arranged horizontally for more striking composition

Snakeskin wallet cropped on three sides so that it becomes a second background material

Only black and silver items used for striking yet harmonious effect

Circular watch and rectangular lighter juxtaposed

Watch set against gray to stand out

Watch's hands set at an interesting angle at a time that suggests the start of an evening

Off-center cuff links add interest to otherwise static composition

Cuff links positioned so that reflection is not an even flat white

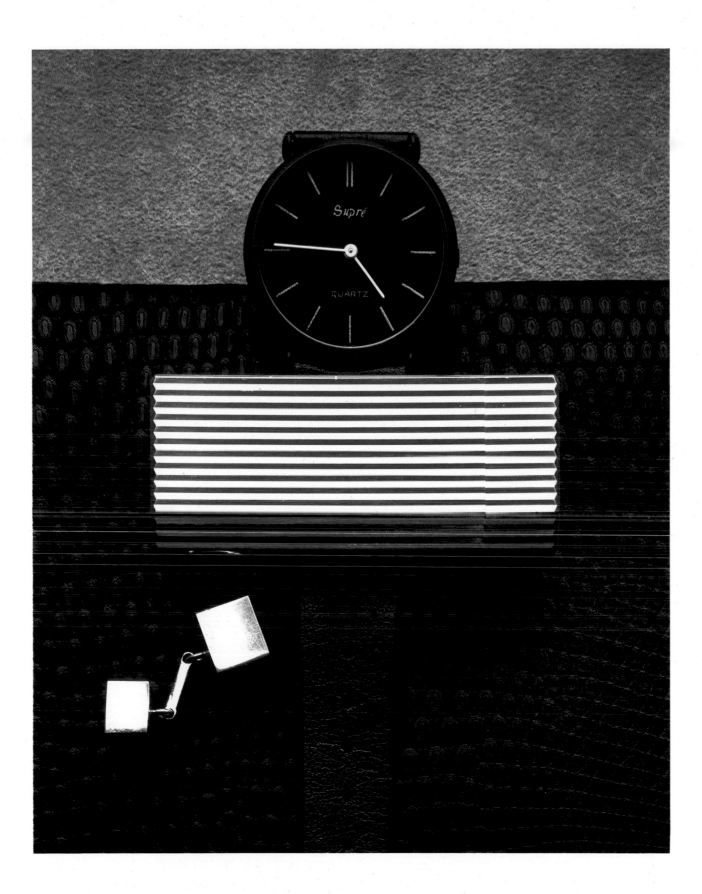

A DELICATE AND HARMONIOUS ARRAY

I also made this shot for *Gentleman's Quarterly* magazine. It was one of three spreads of women's clothing and accessories presented as suggestions for presents. This may be the only time the magazine ever featured women's clothing. The image involved a design problem rather than a photographic problem because I had to choose from hundreds of accessories, and arrange them appropriately. There were about two dozen items in this image and it was essential that they all work well together. With that many items, I find it best to use a fairly regimented arrangement, with all but a few items positioned with geometric precision. Beyond that, it's often simply a matter of picking and choosing objects and arranging them in trial-and-error combinations on the set until you find a group that works well together.

I used neutral white tubing that went well with the spring clothing for the background, changing the color on the other two featured spreads. The composition was arranged with attention to how the colors interacted. I chose items that harmonized with the violet and blue scarf. Violet, white, and blue sweaters, purple powder puffs, and neutral elements seemed to

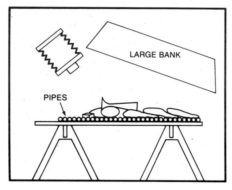

blend naturally. Had I added other colors, the pictures could have become too chaotic and the colors would have fought each other. I placed the white sweater between the others for contrast and the white blouse against the white background to make the picture lighter in that area. Since a two-page photograph was needed, I made sure that the scarf and blouse traversed the gutter to avoid the impression of two independent pictures. I also made certain that none of the smaller elements fell into the gutter. The set was top lit with one large bank, placed at an angle. I shot nearly straight down, angling the camera only slightly.

Plastic pipes provide a strong linear background

No important item placed at center where image will go across two-page spread

Scarf and blouse cross center holding two halves of image together

Mirror and powder puff placed to form a central focal point

Scarf fanned around powder puff for interest

Sleeve folded back against dark scarf to show off lace

Line of fold in sleeve completes the scarf's circular line

Richly colored and textured scarf forms strong central interest

Blue and purple sweaters echo colors in scarf

Light-colored sweater set off by darker sweaters

Leather goods grouped together

Dark boot placed to form strong horizontal echoing scarf

Angled wallet echoes shape and color of sock

Boot and sock echo colors in scarf

Objects going off edge anchor image and simplify the design

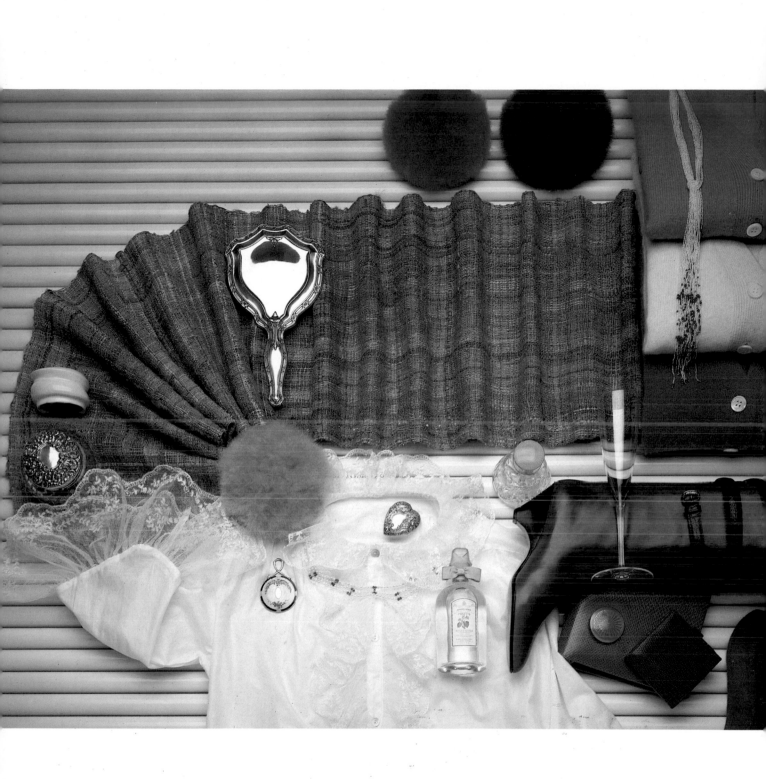

A REFRESHING POOL SIDE ARRANGEMENT

I made this shot of a facial soap, cleansing cream, and skin energizer for Estee Lauder. Since these are bath products that refresh the skin, I wanted to use straightforward lighting and a clean design. I used one basic light source, placed above the set, to assure a high-key effect.

I arranged the sink and faucets myself, purposely not fastening the faucets so that I could move them easily to accommodate changes in the composition. It's important to keep a set flexible. I originally planned a more pristine approach without any water droplets, but I decided that a sense of action and motion would make the picture seem more human. Though the placement of the water droplets was determined by trial and error (I simply sprayed the water on and if I wasn't satisfied wiped the area down and started again), the water in the sink was carefully planned to provide a feeling of movement. To create waves in the water, I used a compressor and hose which sprayed air into the sink to make it appear that the water was rippling.

The color of the water was also very important. I wanted a swimming-pool blue to complement the faucet, which was reminiscent of a diving board. Since plain New York tap water has a greenish hue, I added blue food coloring to distilled, bottled water, which had been mixed with milk.

The soap was another important element in this picture. I whipped up the bubbles in a small bowl and then put them on with a straw. But when the bubbles are layed on they stain the soap and leave a scum, so I ended up shooting about 20 different soaps. I also wanted to enhance the

soap by placing a light underneath it. Because the soap was translucent and I wanted light to shine through it, I had to cut a hole in the tile. Since the soap had plenty of color saturation, I used a straight white light. Even after all this preparation, however, I never found a soap and water that worked well together on the same chrome. So I took a chrome of a soap that I liked and had a retoucher cut the bottom part of the picture, and butted it against the top of a chrome in which I was satisfied with the water. The cut is along the black sink edge, so it can't even be seen.

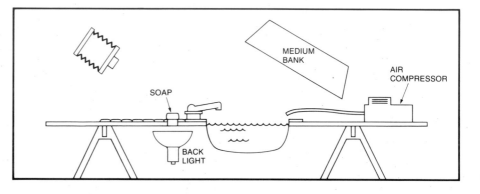

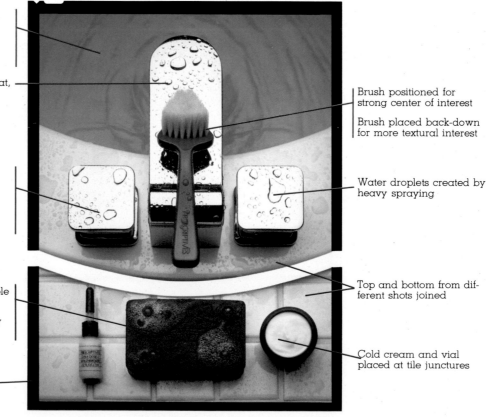

Milk-water mixture with blue food dye

Ripples created by off-camera air hose

Faucet selected for its flat, diving-board look

Fixtures unmounted for easy movement

Fixtures closer together than on real sink for tighter composition

Soap backlit through hole in tiles

Soap bubbles added by straw to fresh bar

Grout lines cropped off at edges

Brush positioned for strong center of interest

Brush placed back-down for more textural interest

Water droplets created by heavy spraying

Top and bottom from different shots joined

Cold cream and vial placed at tile junctures

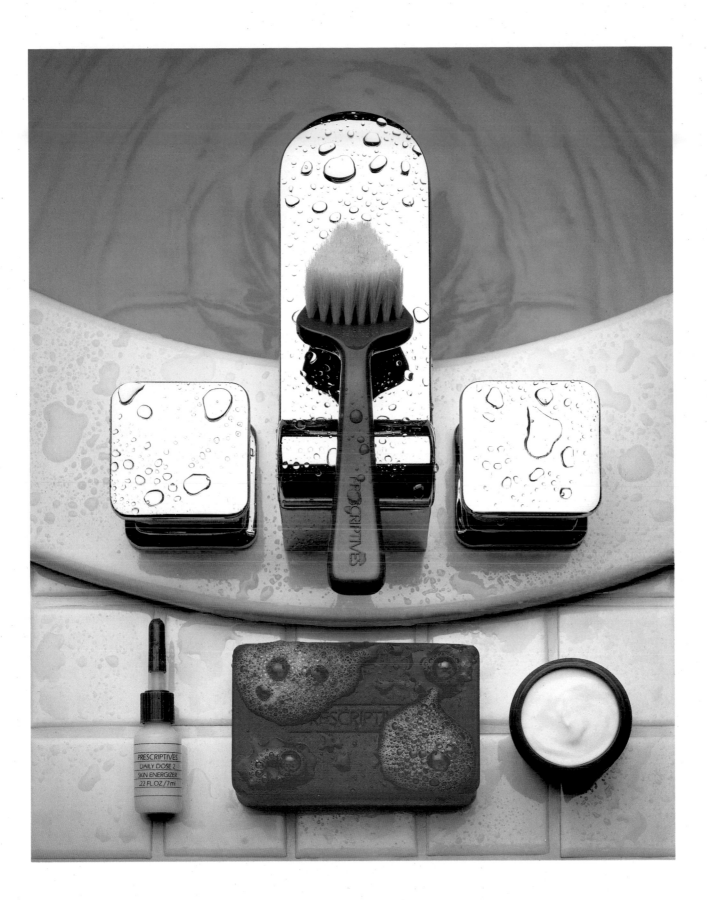

Part Four
FOOD AND DRINK SHOTS

Photographing food and beverages is one of the more challenging aspects of the still life photographer's job. There's lots of little tricks involved, but the photographer must always be aware of the rules of truth in advertising. If you're hired to shoot a generic soup, ice cream, or cake, you can do anything you want to make the product look appetizing. You can add marbles to the soup to make vegetables float to the top or acid to a hamburger to make it smoke. But if you're photographing Campbell's Soup or a McDonald's burger you can't alter them a bit. If the vegetables don't float by themselves they just have to stay at the bottom and the smoke has to come off the burger from actual heat. So if you're making a generic shot you can really go to town, but if it's for a specific product you are legally responsible to portray the truth.

When you're shooting food you need to have the assistance of a good stylist or home economist. She or he will generally gather the props and style the food on the plates. You need to find a stylist who's in tune with your way of thinking, so I always use a stylist whose visual aesthetic is much like my own. You also need a versatile person because one day you may be shooting a very high-tech image and the next day the set may be Louis XIV. I always ask my stylist to gather more than enough props for a shoot because I like to keep my options open. If I need a glass plate, she'll come in with a variety of plates in different shapes and sizes so that I have the freedom to experiment during the shoot. Props should be chosen with practicality in mind as well as aesthetics. I often use a short glass, or cut the glass down to only a few inches, so that I can keep everything in focus. And I try to avoid curvey, tulip-shaped kinds of objects because they reflect light from too many different directions.

Lighting food requires a lot of forethought. When you're dealing with substances like chicken or beef it's not as simple as shooting a piece of chrome with a little fill. The light should be mod-eled, but clean. Certain foods, like parsley for instance, have a tendency to photograph dark, so I try to choose a piece that's on the light side to begin with. Drinks like wine or liquor often require special lighting because the liquid may appear darker and denser than the glass that it's in, and light won't pass through to illuminate it as easily. Whenever possible, I try to solve this problem by diluting the liquid. Or, if the rules of truth in advertising present a problem, I pump more light through the portion of the glass or bottle that holds the liquid.

Food and beverages require a certain amount of wizardry to pull off the delicious illusions we still life photographers are expected to create. I have a few favorite tricks that I use when I can, like putting grill marks on a steak with a hot iron, heating coffee to the boiling point in a microwave to get steam, painting a turkey or chicken with Kitchen Bouquet for a warm glow, adding glycerine to alcohol to create bubbles, or painting vegetables with it to give them a wet shiny appearance. Ice cream is one of the most difficult foods to photograph. You have to keep it very cold, perhaps even spray it with Freon. But if it doesn't have a little melt around the edges of the glass or dish it's in, it doesn't look real. I always add the melt with a stick after I've put the ice cream in the glass. I like to use a little eggbeater to whip up the head on a beer, and when I pour a substance like beer I prefer a very turbulent pour so I plug up the neck of the bottle with my thumb and fill it all the way up with liquid from the back. When I release my finger the atmospheric pressure building up in the back of the bottle pushes the liquid out and I get a clean, strong pour.

Making food look good in a picture is an art, and props, lighting, the stylist, and whatever helpful tricks you're allowed to use are all important factors. Sometimes the illusion is so convincing that the food looks good enough to eat right after the shoot. But my cardinal rule is to *never* eat the food on a set, because *anything* could be in it.

A FLAVORFUL TOUCH FOR A PIE

I made this photograph mainly because I like strawberries—their rich color, sensuous texture, and of course their taste. For a unique approach I photographed the strawberries in this tempting little pie. The most obvious way to photograph a pie is to plunk it in the middle of the composition, but I opted to approach this shot a bit differently, placing the circle of the pie off center and adding some weight in the right-hand corner with few random berry halves. The photo shows that even a set featuring only two or three objects can become versatile with imagination and a bit of maneuvering.

To create the perfect pie, I asked a home economist to do a lot of baking. She glazed her pies a deep red and added a cream edging for a pure white contrast. I touched up the strawberries with glycerine so they would keep their shine, and placed the pie on a 30 × 40-inch silver show card. I used a silver background to create greater contrast in the water droplets and the shadows. On a white background the droplets' edges and shadows would have appeared very

soft. Though the silver looked white when it reflected the overhead light, it caused a distinct outline around the droplets and also made the reflection cast beneath the pie very dark, separating the white whipped cream from the background. I buffed the silver knife with emery paper to make it matte—I wanted the knife to contrast with the background rather than fade into it. Then I placed two of the extra berry halves cut-side up to add a different, but related, texture, leaving the other one with its outside up.

The shot was lit with one top light and a small fill card at the front of the set.

Silver background becomes white under overhead light

Strawberries coated with glycerine for sheen and deeper color

Pie placed off-center to create interest

Droplets and cut strawberries add more casual feel

Strawberries arranged to echo pie's curve

Insides of cut strawberries add different texture

Water and glycerine mixture for drops

Silver background produces black outline on droplets

Silver background produces deep shadow, setting off pie

Knife blade buffed with emery paper to dull it

Red handle repeats strawberries' color

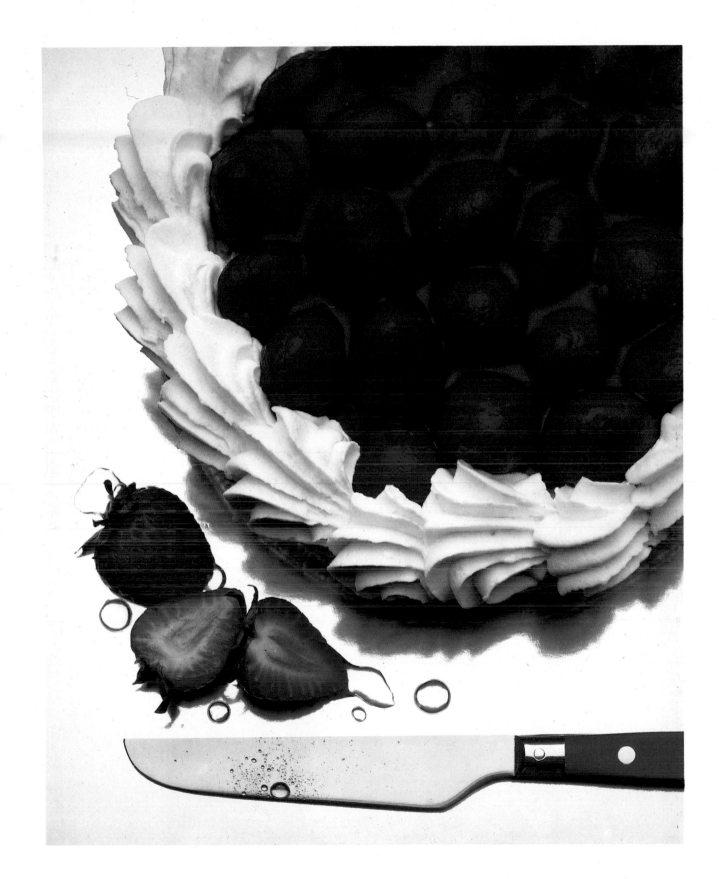

A BALANCED ARRANGEMENT OF SOUPS

These winter soups were shot for *Cuisine* magazine. I was given carte blanche, so I chose black tile for the background to contrast with the white crockery. The black background and white accessories juxtaposed so effectively with the colorful dishes that they asked me to use the same approach for the shot of pies (shown here) that appeared in the following issue. Generally, I try to use color to emphasize the product or key element in a picture, so background, props, or other elements should be neutral, if possible, in order not to conflict. I shot this straight down for a good view of the soups.

My stylist amassed a selection of bowls and silverware and then I chose these different-sized circles, rectangles, and squares. I placed the bowls on various rectangular saucers to separate them from the background—otherwise there wouldn't have been enough contrast in shape. I made several shots, experimenting with different soups in different bowls until I reached this particular combination. Originally, the editors wanted to see the large red soup in the center, but

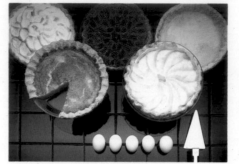

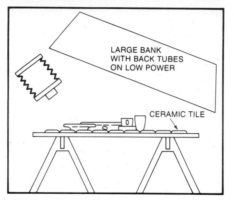

LARGE BANK
WITH BACK TUBES
ON LOW POWER

CERAMIC TILE

it was too strong there and overpowered the other, less colorful soups. So to balance the picture properly I put the pasta soup in the center, with the red soup cropped out of the frame at the top.

Since we weren't shooting this for an advertisement it was okay to cheat a bit with the soups; we placed Lucite cubes in the bottom of the bowls to get the ingredients to rise to the surface, and visually they create an organic kind of tension. I chose the spoons for their interesting shapes and added a vase and orchid for an exotic touch. I also selected a napkin with a design that repeated the form of the orchid and that complemented the squiggly shapes in the soup. Because the soups were so busy, the plain tile background was a necessity for this shot.

I lit the set with a large bank light overhead. There are four long flash tubes inside my bank, which are shaped like fluorescent tubes, and I put the two in the back on a low power setting and the two in the front at a higher setting. This caused a light fall off toward the back of the image, thus creating the gradation in the reflections on the tile. Otherwise, they would have appeared very flat and uninteresting.

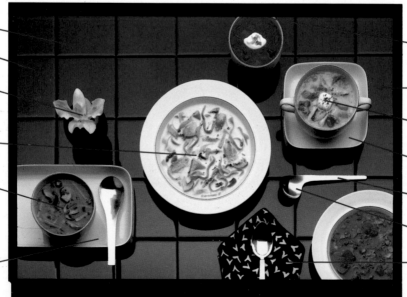

Space left for type

Fall off of light created by using tubes of different power in overhead bank

Orchid softens geometrical arrangement

Elements in soups put in pleasing, balanced arrangement

Lucite cubes put in bowl bottoms force contents to surface

Large saucer balances greater weight on right side of image

Red cut off at edges of frame to avoid overpowering other colors

Black ceramic tile background makes white dishes stand out

Butter pat melted slightly with a heating element

Saucers separate thin-edged bowls from background

Long highlight from large bank

Spoons selected for their unusual shape

Napkin pattern echoes shape of the orchid

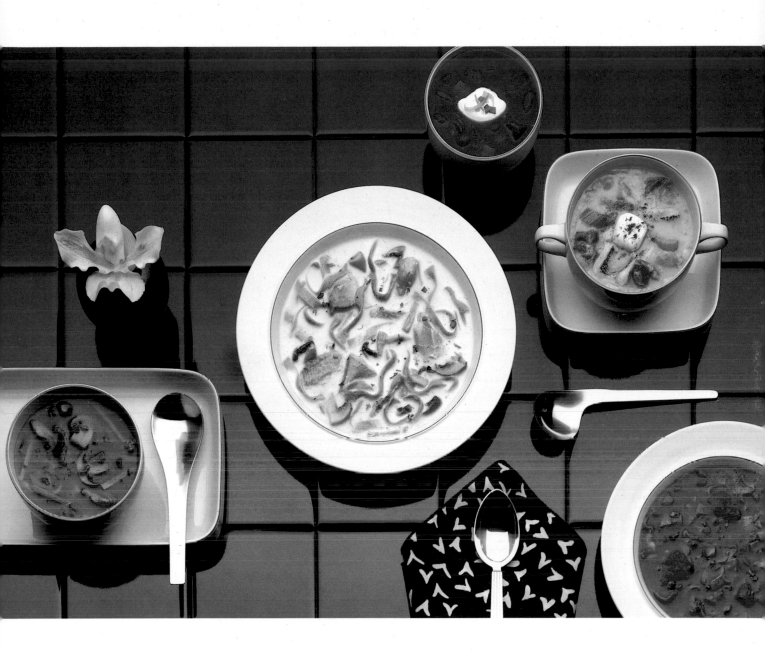

AN INTERPLAY OF RICH CHOCOLATE

In this photograph, made for Perugina Chocolate, I combined bittersweet and milk chocolates with walnuts to emphasize the appetizing taste of the subject. Rather than shooting a flat picture, I wanted to create a strong sense of dimension, as if the chocolate was drawing the viewer into the set.

I went through all kinds of chocolates to find shapes, colors, and patterns that went well together. The background was made of liquid chocolate, which was poured into a cookie sheet (when shooting perspective, you want a background that is longer than it is wide). I elevated the chocolate bar above the liquid chocolate on a block of plastic, at a height that would allow for an effective reflection. I placed a piece of dark chocolate on the milk chocolate, with a walnut shell on top. A whole walnut was centered at the base of the chocolate bar and I scattered some broken chocolate pieces on the milk chocolate to vary the textures and add some tension to

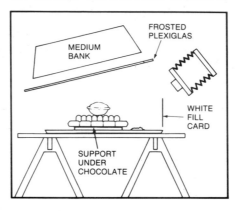

the photograph. I used an eyedropper to add some bubbles to the background, so that it would be clear that the chocolate underneath was liquid, rather than plastic, or some other shiny surface.

To avoid a hard edge, I lit the set with a round top light diffused through a sheet of plastic. The top light provides the reflection on the background and I also used a slight fill for the foreground walnut. To provide a greater sense of foreshortening and add to the illusion of depth, I shot with a wide-angle lens at a medium camera angle.

Wide-angle lens causes subject to recede rapidly

Walnut's natural texture contrasts with pattern in chocolates

Diffused top light prevents hard edge

Chocolate scraps add off-balance interest

Walnut and bubbles break up smoothness

Walnut's front edge filled by small card

Light drops off in background for dramatic effect

Liquid chocolate syrup in cookie sheet forms background

Patterns contrast with smooth liquid chocolate

Bar's reflection increased by raising it

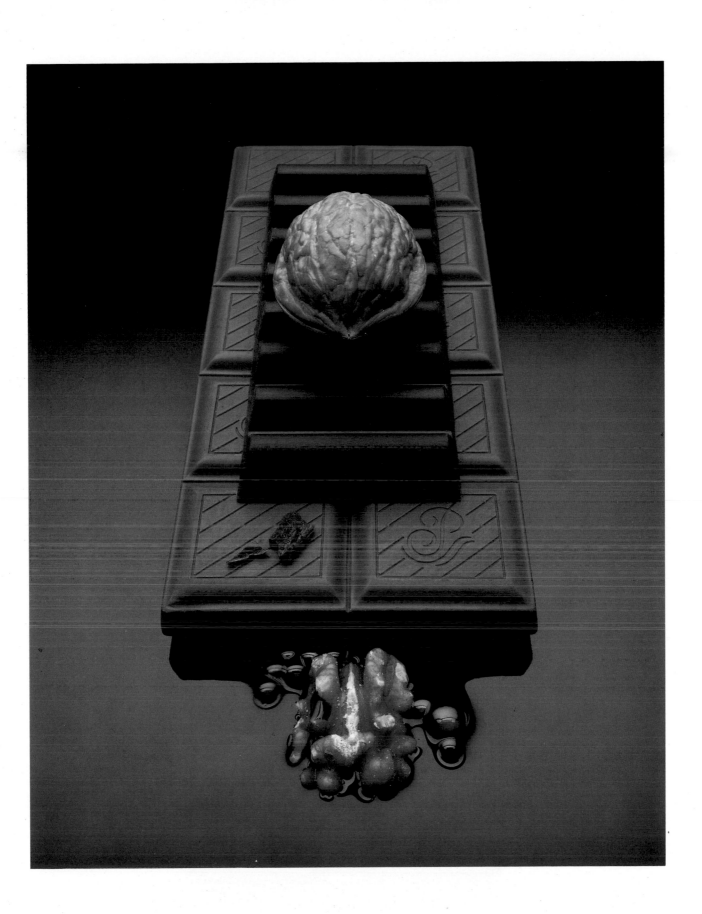

A SUMPTUOUSLY SIMPLE LIQUOR SHOT

For this photograph of a manhattan, I wanted to shoot a free-standing glass, but since this is such a common still life subject, I needed an original approach. I decided to concentrate on the theme of roundness created by a cherry, so I looked for a glass that would complement that idea. I also opted to arrange the set on a frosted light table—a piece of photographic equipment that is used every day—that would create a totally unique effect when used in this manner.

The glass I chose is really a desert glass with a small round dot in the center of the stem. I hung the cherry over the edge and positioned it in the center so it would line up with the circle at the bottom of the glass. I used glycerine to make tempting little pools of liquid on each side of the glass. It was filled with a combination of vodka and tea to lighten the actual color of a true manhattan, which would be too dark to be recorded using the lighting technique applied in this shot.

The frosted light table swept up at the back and down at the front, with a central horizontal area of about three feet. I placed a piece of black velvet on top of the table and covered it with a sheet of clear acetate. I put

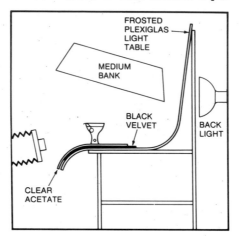

the glass on top, with my camera positioned just a bit below eye level. I backlit the glass with one round head through the back of the light table, and placed a 2 × 3-foot bank light above the glass. The combination of back and top lighting created a nice modulation of light in the liquor. The cherry was refracted in the liquid, creating an arc directly beneath it. The circular trademark inside the glass picked up all the colors of the refracted light, creating an interesting pattern, and the acetate picked up a very small reflection of the whole glass. This series of refractions and reflections made a potentially straight shot into an intriguing pattern of colors and shapes.

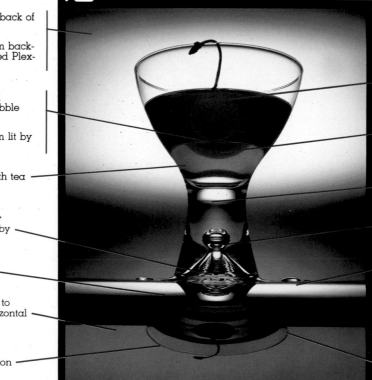

Frosted Plexiglas back of light table

Circle of light from backlight behind frosted Plexiglas

Cherry positioned directly above bubble in stem

Edge of cherry rim lit by backlight

Vodka colored with tea

Liquid and cherry shapes refracted by bubble in stem

Highlight from overhead light

Black velvet ends to create strong horizontal supporting glass

Curve in acetate condenses reflection of glass

Liquid hides back rim of glass

Cherry magnified by liquid into gigantic arc

Reflection of overhead light in center of stem

Crystal bubble repeats circle of cherry

Pools of glycerine add casual, off-center interest

Low camera angle makes subject more prominent

Low camera angle makes light table's front edge look like bar

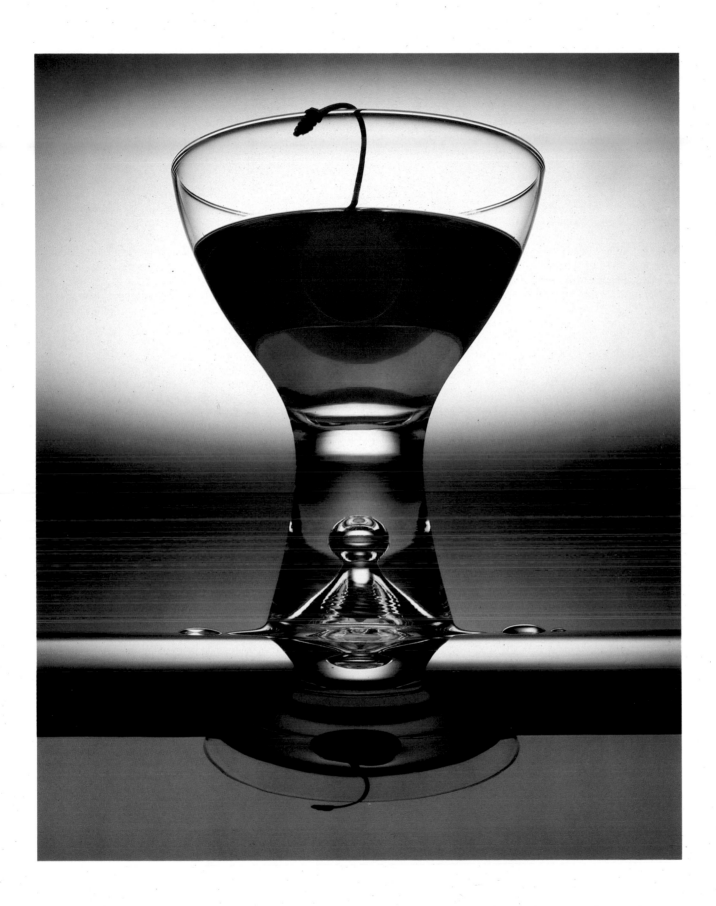

WHISKY ON THE PLASTIC ROCKS

I made this sample shot as an experiment with the qualities of model-made acrylic ice cubes. The shape and character of an ice cube is remarkably important to the success of a beverage shot. It's important to have ice of various sizes and shapes for different sizes and types of glasses. If you used a perfectly square cube in a soda, it would be too smooth and would disappear when the liquid was added. But dents, bumps, and other irregularities refract light so that the cubes are visible when the liquid is poured. It's also essential to experiment with the position of the cube inside the glass in order to make the best of the light it reflects and transmits. If the cubes are too flat the liquid will look too light when light passes through the cube. This same problem can become an asset. The cube acts as a fiber optic, and light coming through the cube will vary the intensity of a dark liquid, enabling you to create a dramatic shot without diluting its color with an additional clear liquid. The ice was carved with tools similar to those a dentist might use—the model maker carves the cube and adds cracks to the inside, later polish-

ing it on a jeweler's wheel to smooth out the scratches.

I used acrylic drops rather than glycerine for the water at the bottom of the base ice cube because acrylic can be moved around without disrupting the set. Since I shot this on a light table with a sweep in the front and the glass was positioned on the edge so that the camera angle could be below glass level, the glycerine would have run down the sweep.

The shot was bottom lit with a strip light to create the modulated surface, top lit with a medium bank, and side lit to add a highlight. I used a gold fill card behind the glass. I placed it on a wire that is snaked around the glass and ice so it can't be seen. The card was topped with a piece of silver card to brighten up the top cube. I used black cards on either side of the glass to block the lights and to keep the ambient illumination from spilling onto the black background. When you're shooting on a light table the object must be fairly small—otherwise you have to raise the lights up too high and it's impossible to prevent the light that strikes the object from spilling onto the background.

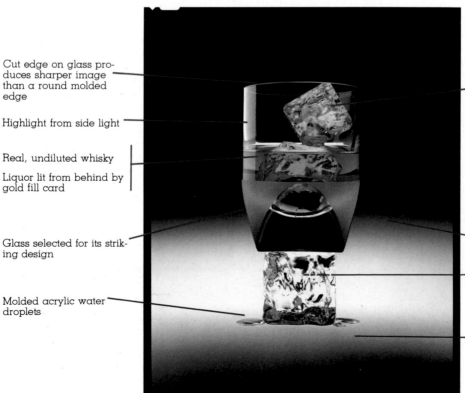

Cut edge on glass produces sharper image than a round molded edge

Highlight from side light

Real, undiluted whisky

Liquor lit from behind by gold fill card

Glass selected for its striking design

Molded acrylic water droplets

Top ice cube helps balance one under glass

Cube lit from behind by silver fill card

Cubes of different sizes used for variety

Bumps and dents on plastic ice cubes refract light, making cubes visible

Light falls off at back of table

Fill cards supported on wire behind cube

Frosted plastic surface of light table lit by bottom light

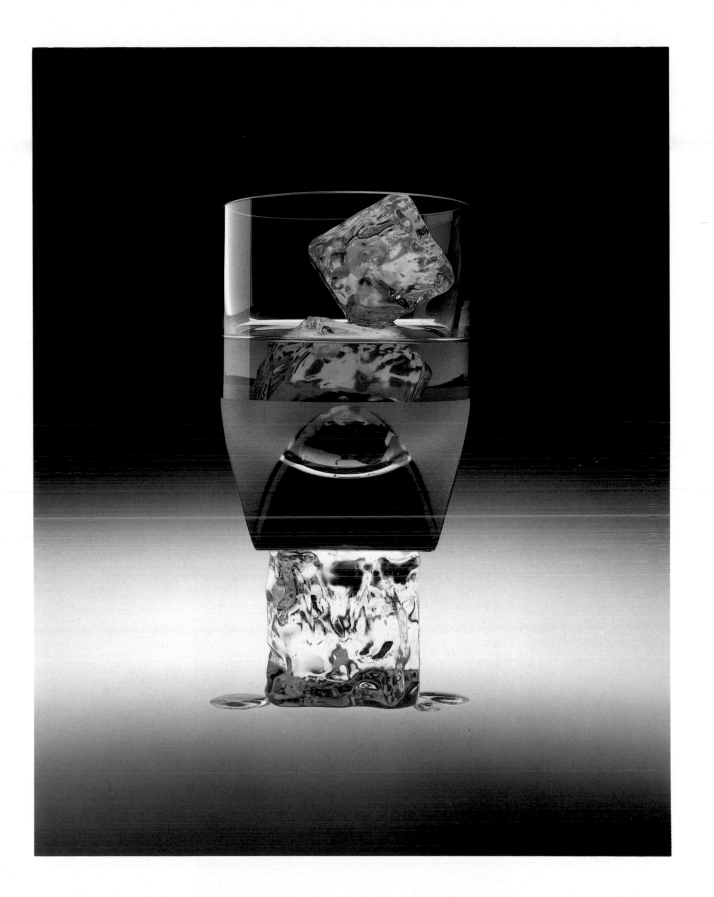

WHISKY WITH A GAMBLING THEME

I shot this symbolic picture for *Meeting and Conventions* magazine. It was used to illustrate an article on gambling, so I chose liquor, a cigar, dice, and an ace of spades as the elements, which I felt would conjure up the right mood.

I pre-burned the cigar to get the ashes just right and placed it across the top of cut-edge glass, in place of a rolled edge glass, filled with liquor and Lucite ice cubes. I like to use cut-edge glass because it reflects as a straight, hard-white line underneath a top light. I used a piece of pipe, sprayed black, for the base, but the glass was actually resting on a small platform positioned behind the pipe. I placed the playing card and poker chip beneath the glass. Since the image would appear as a one-page illustration, I wanted to keep the elements centralized. I put the glass and card within close proximity to create a solid visual unit, and arranged the dice outside of the unit to break up

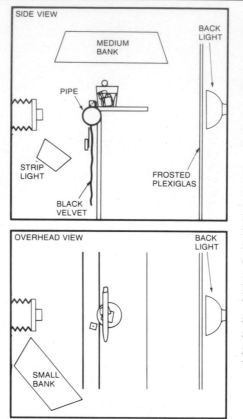

the space on the outer edges of the frame, as does the horizontal placement of the cigar. The cigar and poker chip also serve to break up the centralized composition at the top and bottom. I used a sheet of frosted Plexiglas in the background to prevent reflections from bouncing off the foreground, and hung a sheet of black velvet beneath the pipe.

A top light brightened the cigar and glass. To create the glow behind the glass and to illuminate the liquor, I used a light in the background, shining through the Plexiglas. A strip light in the low front lit up the playing card and poker chip, and cast a highlight on the pipe. A pleasing reflection on the playing card cast a second little highlight along the bottom of the pipe. The highlights on the glass were created by a side light on the right and I angled the camera a bit below the glass so both its back and front edges would be visible.

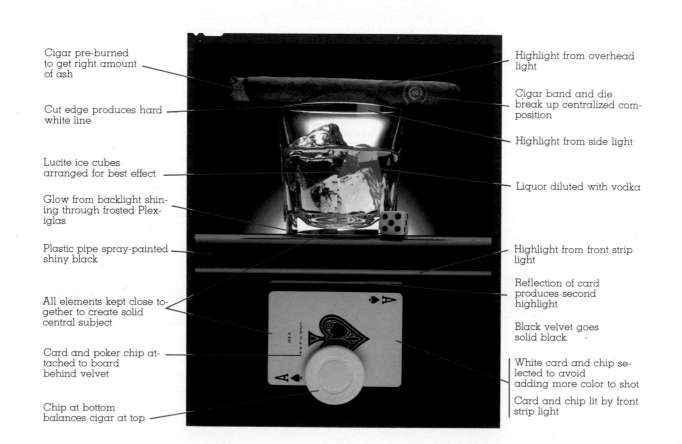

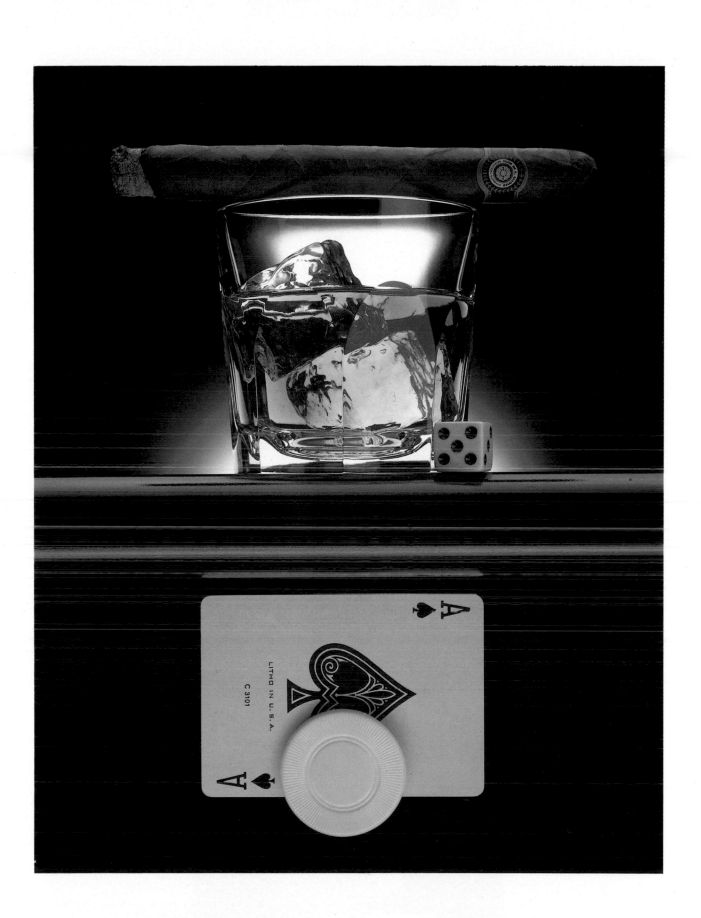

A SWASHBUCKLING IMAGE FOR A GINGER BEER

Old Tyme Ginger Beer had a new label and the company was trying to reintroduce the product in an exciting way. They wanted a swashbuckling theme, so I incorporated a shiny silver sword handle to go with the pirate imagery on the label. I accentuated the silver and amber hues and added a glow around the bottle to make the product look almost as if it were emanating an inner light.

I placed two flex straws, sprayed silver, in the bottle of ginger beer, which rested in the handle of the sword. The only color in this shot is that of the product. The blade section was clamped to a stand out of view, leaving the handle and bottle freely suspended. The bottle and sword handle were sprayed with water to suggest the ocean and make the ginger beer look thirst-quenching.

A side light lit the left side of the bottle, and a fill card was used on the right side so the rest of the bottle wouldn't be in total darkness. This

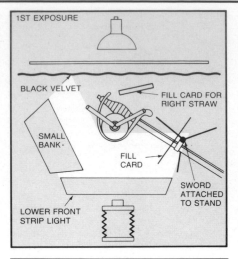

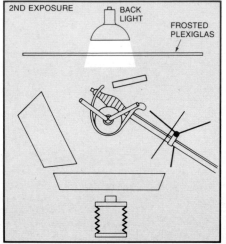

also highlighted the right-hand straw. A strip light was placed low at the front of the set, creating highlights on the straws and sword, and I placed another tiny fill card overhead to put a highlight on the top of the right-hand straw. A small back light, shining through frosted Plexiglas, put the glow around the bottle and lit up the inside to accent the amber hue of the liquid.

When you put a glow around a subject like this, you generally have two choices. One, you can put the back light far enough away from the subject so that the Plexiglas in front of the back light doesn't pick up light from the front lights. This sometimes requires that you use a fairly large light at an awkward distance. The other choice is to make a double exposure, which is what I did here. You drop black velvet in front of the Plexiglas and expose the foreground. Then you remove the velvet and expose the back light.

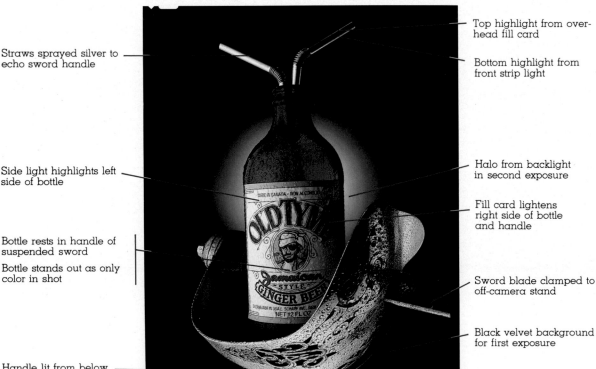

Straws sprayed silver to echo sword handle

Side light highlights left side of bottle

Bottle rests in handle of suspended sword

Bottle stands out as only color in shot

Handle lit from below strip light

Top highlight from overhead fill card

Bottom highlight from front strip light

Halo from backlight in second exposure

Fill card lightens right side of bottle and handle

Sword blade clamped to off-camera stand

Black velvet background for first exposure

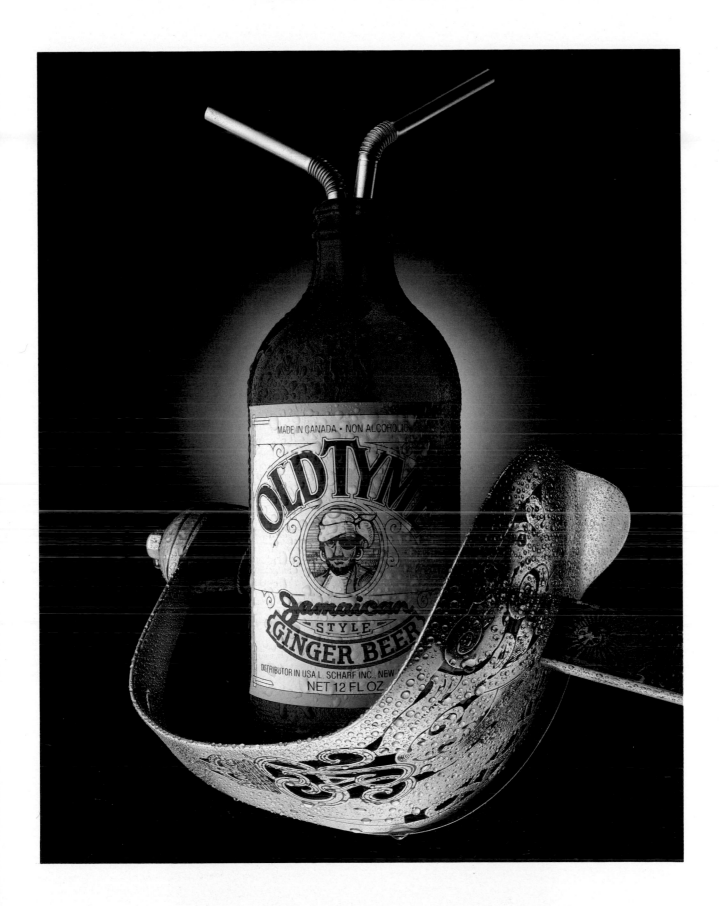

A ROMANTIC EVENING WITH AMARETTO

For Amaretto di Saronno, I wanted to create a setting that would suggest a romantic encounter—even though no models would be used. I thought a moonlit night and two glasses, one of which would be overturned, would give the impression that two people had been enjoying Amaretto before they went off to enjoy something else.

The bottle and glasses were placed on a piece of PVC piping, which I had sprayed black. A swatch of black velvet was draped beneath. To make sure that the color of the liquid in the bottle and the glass would be identi-cal, I mixed a lighter-colored alcohol into the Amaretto in the bottle. Otherwise the light passing through the liquid of the bottle would have been unbalanced, and the bottle would have appeared to have contained a much darker drink. Lipstick was smudged on the overturned glass.

The main light source was placed above the set. I also used a bottom strip light to create a continuous high-light along the piping, and a shiny silver card to put a highlight on the bottle. A circular back light, shining through a piece of frosted Plexiglas, created the glow, which separated the glasses and bottle from the dark background. And for the stars and moon, I used another large back light, covered with a piece of black paper velvet into which had been cut holes for the stars and the crescent.

This lighting setup required three exposures; I dropped black velvet in front of the background and exposed the foreground in the first shot. Then I exposed the glow behind the bottle. In a third exposure, I dropped in the second back light and shot the stars and moon. A star filter was placed over the lens to create the twinkle effect.

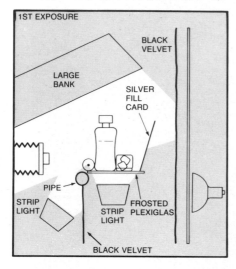

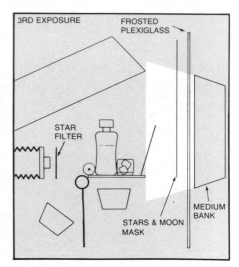

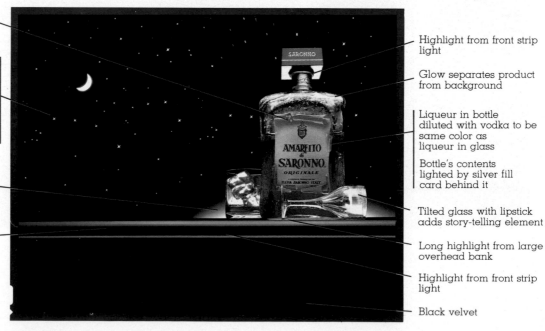

Foreground recorded during first exposure by overhead and front lights

Stars and moon recorded during second exposure by large backlight

Moon and stars are holes cut in black paper

Stars' twinkle created by star diffraction filter

Glow from small back-light during second exposure

Plastic pipe spray-painted shiny black suggests a bar

Highlight from front strip light

Glow separates product from background

Liqueur in bottle diluted with vodka to be same color as liqueur in glass

Bottle's contents lighted by silver fill card behind it

Tilted glass with lipstick adds story-telling element

Long highlight from large overhead bank

Highlight from front strip light

Black velvet

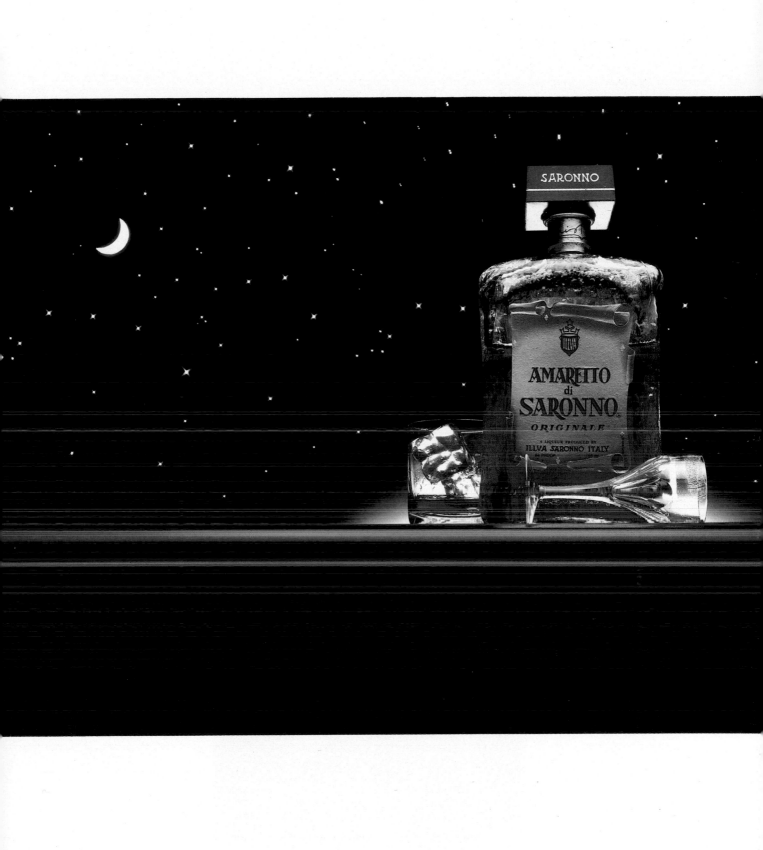

A DYNAMIC CASCADING POUR

In this shot of water cascading over the edges of a glass, I wanted lots of action. I positioned the glass and bottle so that they would bleed off the page and used the lemon and cherry as the central color elements. Both the glass and bottle were clamped to separate light stands so neither would move.

I chose a perfectly shaped, bright-red maraschino cherry, and a thin slice of lemon. Because the lemon was too pale for my purposes, I placed a yellow gel behind it.

Even though the cherry and lemon were the smaller elements in the picture, the image reveals the incredible power of color, for the eye is drawn directly to the two striking hues.

I placed a Rosenthal glass at an angle, and cut the back off the bottle so water could be poured through

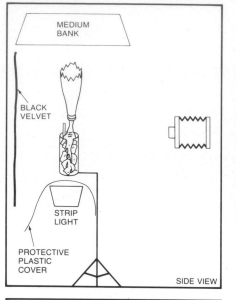

again and again until I was satisfied with the shot. I spritzed the glass with water and filled it with large Lucite ice cubes, and positioned the glass and bottle at diagonals to add to the sense of movement. The pour was achieved by trial and error until I captured the cascading impression I was looking for—the glass was pre-filled almost to the top to facilitate the overflow. As I poured water into the open base of the bottle my assistant stopped the mouth with his thumb. Just before I shot he removed his finger so the water would come bursting out.

I lit this photograph with a medium bank overhead and a strip light below. I also used a small bank on the right side and a fill card on the left. The background was black velvet.

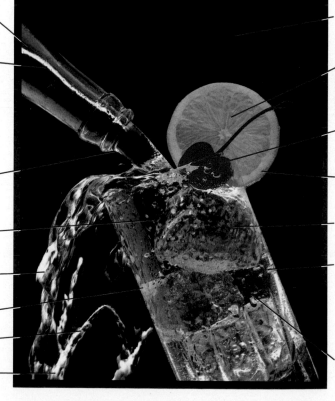

Bottomless bottle held by off-camera stand

Highlight from fill card overhead

Water in bottle released an instant before shot was taken

Glass pre-filled with water

Flash duration adjusted to freeze most of cascade

Highlight from sidelight

Water overflows to fill negative space

Highlights on water from bottom light

Background of black velvet goes solid black

Lemon sliced very thin for translucence

Yellow gel behind lemon adds color

Cherry selected for its bright color

Fruit fills space, balancing water

Lucite ice cubes

Glass and bottle sprayed with water

Glass and bottle angled to form dynamic diagonal design

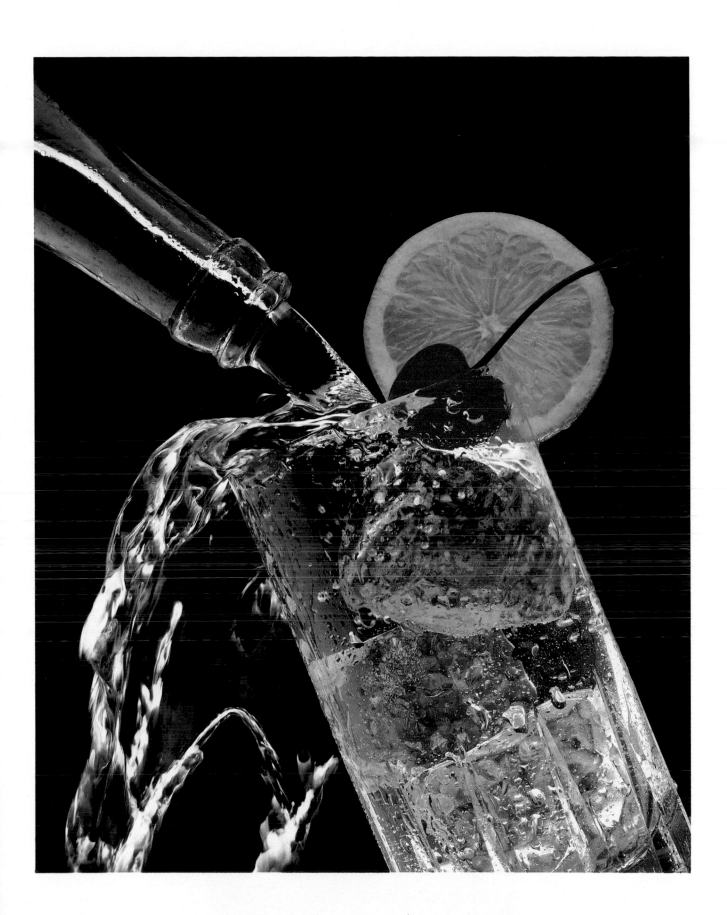

A CONTROLLED BEER-POUR SHOT

In this picture I was trying to deal with two main concepts. I wanted a very frontal, flattened out shot, and I wanted to play off color against a neutral background. I always try to use a minimum of color so that the eye goes directly to the most important element in the photograph.

Instead of a tall, conventional beer glass, I spritzed a big brandy snifter with water and cropped the stem off. I sprayed a piece of plastic piping with high-gloss Krylon paint and placed it just at the base of the set so the stem of the snifter was out of view. Then I hung a piece of black velvet, with the peanut attached, below the piping. This gives the impression that the glass is sitting on a bar. The beer bottle was clamped into a perfectly horizontal position above the glass.

Pouring a perfect beer proved to be a challenge. I salted the beer and whipped it up with a tiny single-loop whisk to enhance the head and create the bubbles. I wanted the head to be just the right size in relation to the size of the glass. When you're pouring beer, it's very important to keep the pour from going through the head into the amber liquid because the foam will be pulled down into the beer, causing black lumps. Getting

the right head was a matter of trial and error—it took about 50 pours. It's essential not to get a lot of larger air bubbles within the small air bubbles in the head because that too can create some big, dark holes. I filled the glass nearly all the way to minimize foam, pouring very slowly. Then, to make it appear that the beer is actually being poured from the bottle in the photo, I cut the back of the bottle off, and poured the beer through a tube so that it would force the liquid through the bottle and into the glass without breaking through the head of foam.

As for the beer itself, I prefer it to have lots of bubbles in the amber liquid, even though in many beer adver-

tisements it is supposed to be clear. Personally, I like the bubbles to break up the flat color. Since the bubbles are traveling so fast, however, it's hard to keep them from blurring on the film. I had to shoot the beer at a very low flash setting to capture them.

This shot was lit with several light sources. One light, placed behind the Plexiglas background, created a globe of light behind the glass. A top light enhanced the head and created highlights on the top of the beer bottle and pipe. I placed a gold card behind the beer to give it more luminosity. The bottom light was directed at the peanut and also put a highlight on the pipe.

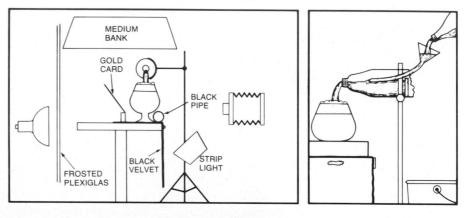

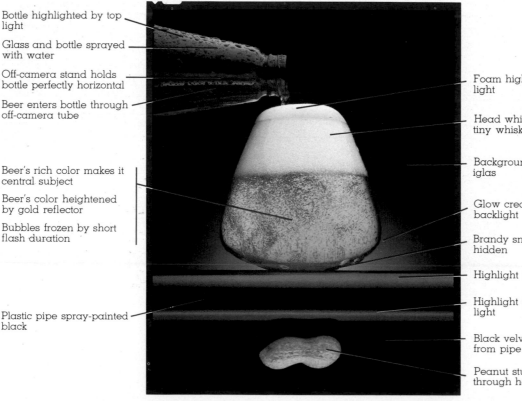

Bottle highlighted by top light

Glass and bottle sprayed with water

Off-camera stand holds bottle perfectly horizontal

Beer enters bottle through off-camera tube

Beer's rich color makes it central subject

Beer's color heightened by gold reflector

Bubbles frozen by short flash duration

Plastic pipe spray-painted black

Foam highlighted by top light

Head whipped up with tiny whisk

Background of clear Plexiglas

Glow created by backlight

Brandy snifter with stem hidden

Highlight from top light

Highlight from bottom light

Black velvet suspended from pipe

Peanut stuck to board through hole in velvet

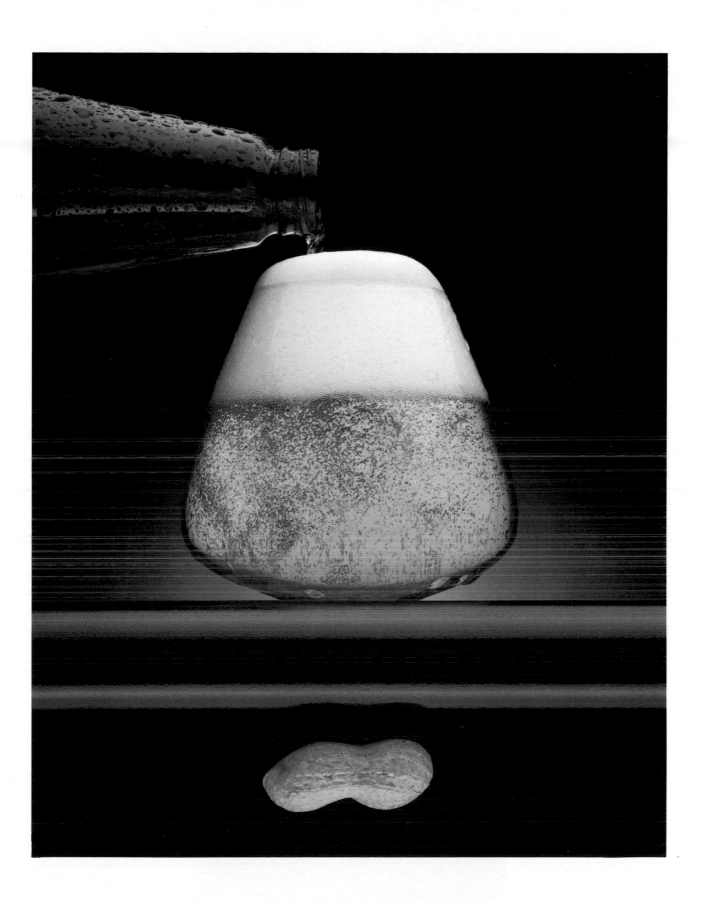

THE GEOMETRY OF AN AFTER-SCHOOL SNACK

It's always simpler to begin each shot with well-designed subjects, rather than attempting to make unexceptional objects look appealing. Of course, this isn't always possible, but when I do personal shots for my portfolio, I choose subjects that appeal to me in terms of design. I photographed this beautiful red cup with a white pitcher of milk, even though it's probably more appropriate for hot chocolate or coffee. Sometimes incompatible objects suddenly harmonize when they're put together in a photograph.

For perfect balance I placed the pitcher directly in the center of the photograph and clamped it into a perpendicular position. I ran a large plastic tube through to the spout and poured the milk in through a funnel. The notch, which made the pitcher's flat white surface more interesting, was positioned off to the right. I placed the red cup on two clamped-together pieces of birch plywood, which were lacquered to bring out the richness of the wood. I liked the contrast in texture that the plywood provided, though I felt it was too dense as one unit. To solve that problem I cut a couple of grooves in the end of

the plywood with a router. I positioned the cup so it jutted over the edge of the wood, creating a sense of tension. The cup looks as if it could fall off at any moment. I chose red and white straws to break up some of the black space created by the black

velvet background.

Because there were so many sharp angles in this composition—created where the cup met the wood and by the lines in the wood—I decided to use cookies to echo the circular shape of the pitcher and to add texture (Oreos are certainly a must with milk, anyway). The vanilla cookies, placed slightly askew, complemented the hue of the birch ply and made the shot seem less pristine.

This photograph was lit with one side light and a fill card. The light was positioned about 6 inches below the piece of wood, so that a highlight would run from the top to the bottom of the cup. When lighting a cylindrical object, the light must be lower than the bottom of the object if the highlight is to travel from top to bottom without interruption. Since the cup was on a precipice I was able to position the light low enough to do this. I was also able to position the camera lower than the wood and yet keep it at straight-on level. The combination of these stylish objects and a single light source resulted in an inviting picture of a food and beverage that complement each other visually, as well as in taste appeal.

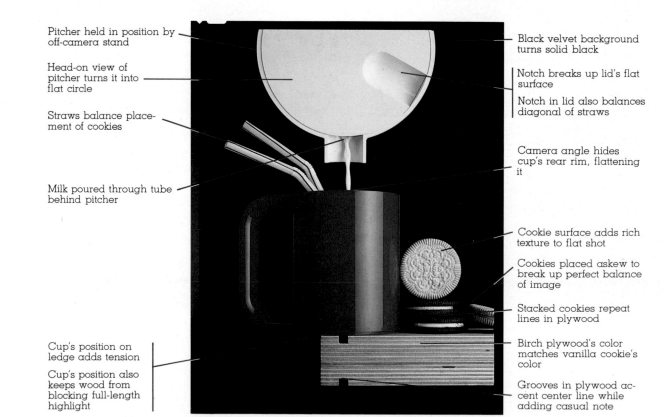

Pitcher held in position by off-camera stand

Head-on view of pitcher turns it into flat circle

Straws balance placement of cookies

Milk poured through tube behind pitcher

Cup's position on ledge adds tension

Cup's position also keeps wood from blocking full-length highlight

Black velvet background turns solid black

Notch breaks up lid's flat surface

Notch in lid also balances diagonal of straws

Camera angle hides cup's rear rim, flattening it

Cookie surface adds rich texture to flat shot

Cookies placed askew to break up perfect balance of image

Stacked cookies repeat lines in plywood

Birch plywood's color matches vanilla cookie's color

Grooves in plywood accent center line while adding casual note

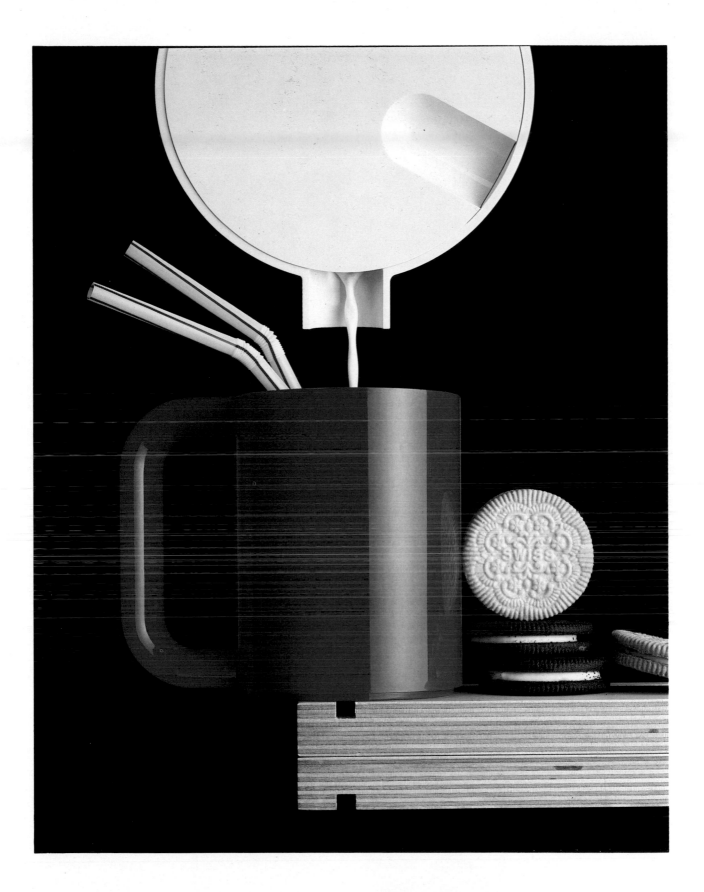

A LIVELY BOTTLE OF PEPSI

In this shot for Pepsi I wanted the cap, opener, and bottle to work together to create a sense of excitement and motion. To set off the red, white, and blue Pepsi label, the other elements in the picture were neutral—silver, white, and black. I often use color only in the product so that the eye will travel directly to the most important part of the picture.

I positioned the cap in mid-air on a wire rod that was covered with black velvet so it was not visible in the final image. I epoxied some Lucite chips to the Pepsi bottle, which I sprayed with water to give the impression of having just been pulled out of a bucket of ice. Then I affixed the bottle on a stand in a steady diagonal position. The Pepsi was diluted with club soda for a lighter consistency. The silver opener was positioned with a clamp in the left-hand corner so it would appear that it was being lifted from the scene.

To achieve the effect of the bursting soda I ran a hose from an air compressor up the back of the bottle. At the end of the hose I attached a ball-point pen casing. The ball had been removed and replaced by a small hook inserted over the tip to make an atomizer, so that when I pumped

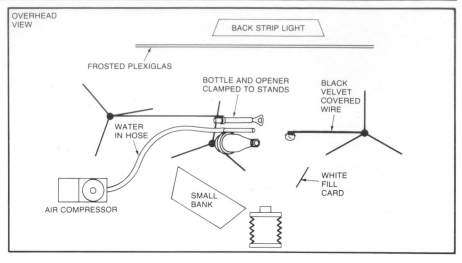

compressed air through the nose the water in the tube would emerge from the tip in an exuberant spray rather than a stream.

To create the modulation of light in the background I lit this image from the rear with a strip light placed behind a piece of frosted Plexiglas. This also illuminated the soda so that the color took on a golden glow. A light on the left side created a highlight on the bottle and label, and a fill card, just big enough to fill the label without casting a highlight on the rest of the bottle, was positioned on the right.

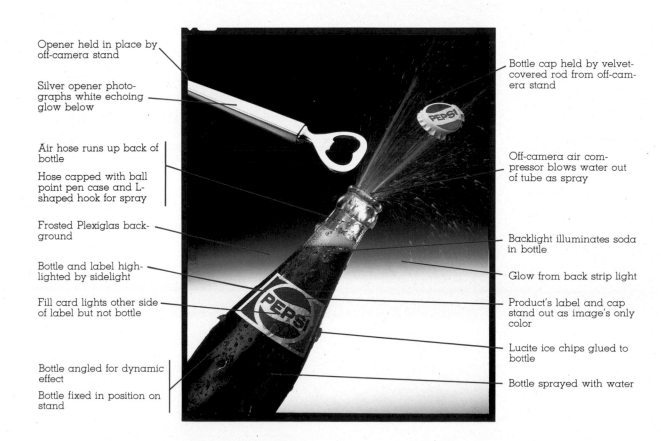

Opener held in place by off-camera stand

Silver opener photographs white echoing glow below

Air hose runs up back of bottle

Hose capped with ball point pen case and L-shaped hook for spray

Frosted Plexiglas background

Bottle and label highlighted by sidelight

Fill card lights other side of label but not bottle

Bottle angled for dynamic effect

Bottle fixed in position on stand

Bottle cap held by velvet-covered rod from off-camera stand

Off-camera air compressor blows water out of tube as spray

Backlight illuminates soda in bottle

Glow from back strip light

Product's label and cap stand out as image's only color

Lucite ice chips glued to bottle

Bottle sprayed with water

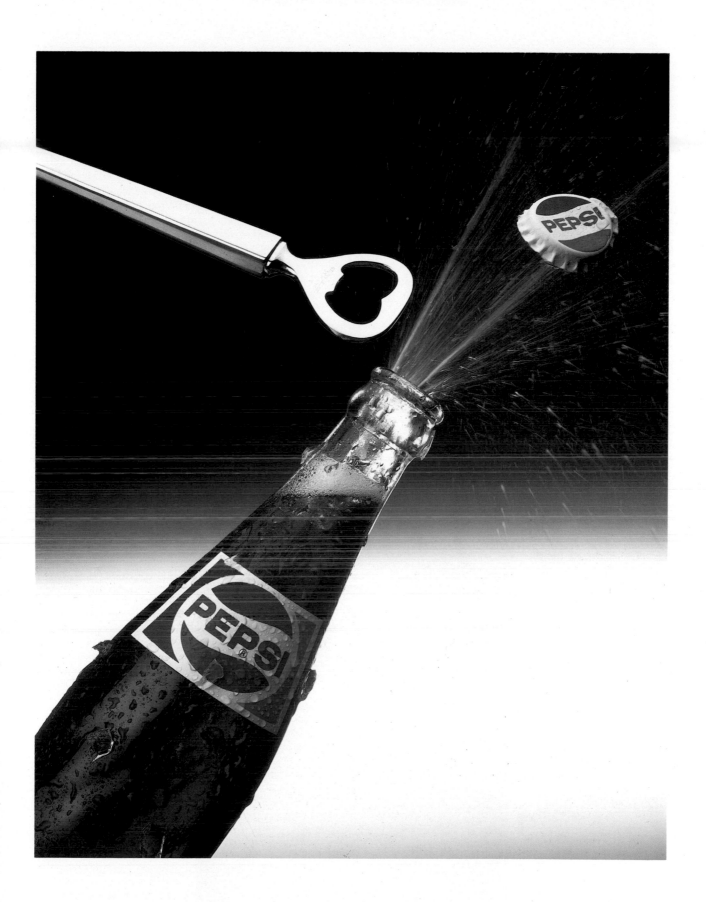

A PERFECT MOUND OF BUBBLES

This is not really a beverage shot but I put it here because the problems involved are basically similar. I wanted to make a generic photograph of some bubble bath, so I turned the bottle around to hide the copy. The design aspects of this shot were fairly straightforward but there were some tricky technical problems to solve in order to make the large, bowling ball-shaped mound of bubbles. I used a more concentrated dish washing soap with a small amount of water rather than real bubble bath. It's easy to make tight, tiny bubbles but to make large bubbles that don't break is a real challenge.

The bubbles were blown into a small clear bowl with a hole drilled in its bottom. I ran a plastic hose from the hole to an air compressor outside the set. As we poured the soap mixture through the bottle, we turned on the compressor and we had bubbles. The position of the hose was critical to the shape of the bubbles. If it was too far to the left, the bubbles would be weighted too much on the right, and vice versa. I wanted the bubbles to be large and curved so I used a big, fat hose rather than a tiny hose, which would have created smaller bubbles. The bubbles had to be constantly reblown throughout the shoot to maintain the circular shape of the mound. Lots of colorful Newton rings

resulted as a happy accident.

This image was top lit, side lit to create a highlight on the pour of soap flowing from the bottle, and bottom lit to help brighten up the bubbles. To create the glow around the bottle I used a pink gel (the same hue as the bottle), placed over a strip light behind a sheet of frosted Plexiglas. The strip light was masked to approximate the size of the bottle. Since this was an action shot, the background glow had to be recorded in the same exposure as the foreground. This made it necessary to put the back light a good 6 feet away so that the Plexiglas in front of it would not pick up any light from the foreground lights.

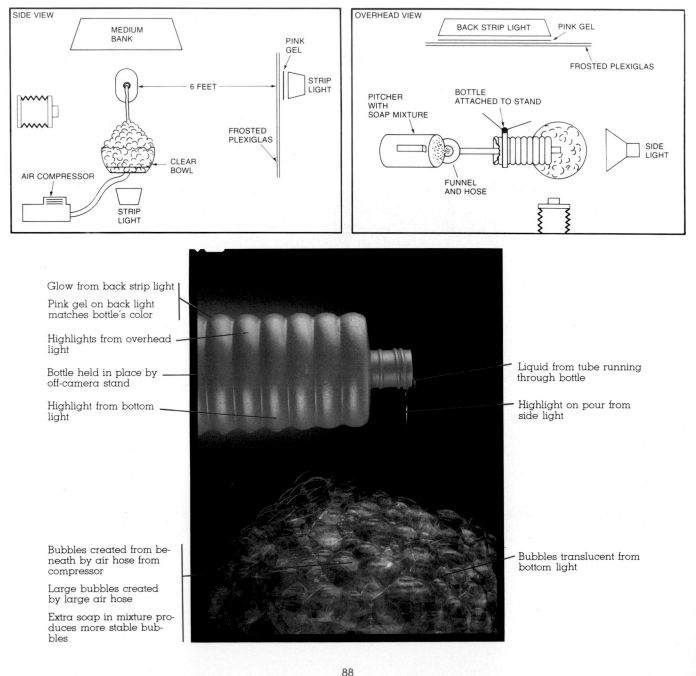

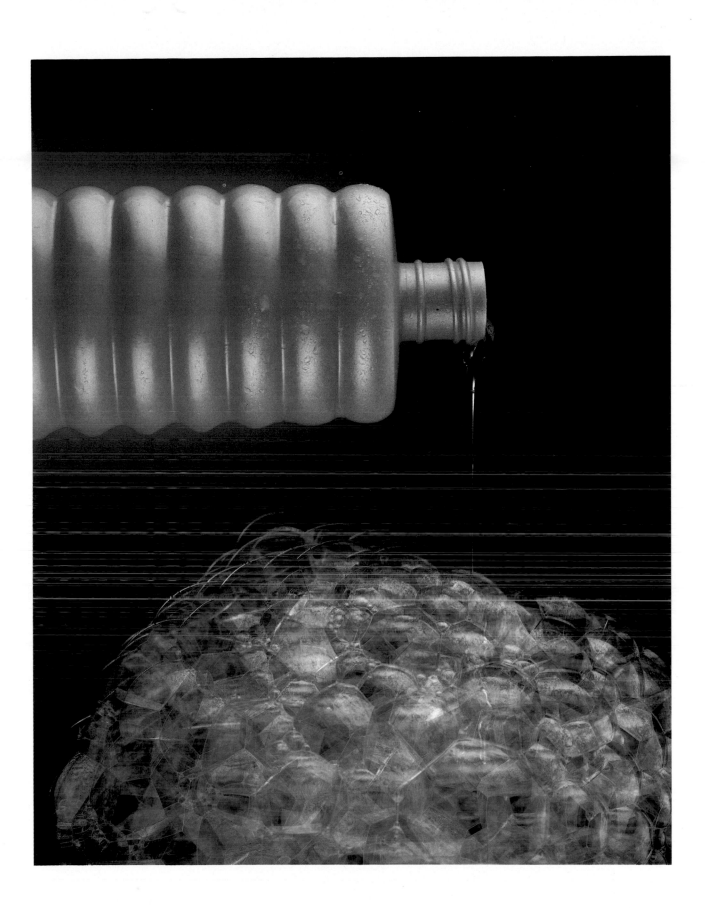

Part Five
ALLOWING FOR AN AD'S TYPE

Many times a photograph will stand on its own—all the photographer must do is create an image that makes sense within the frame. This is certainly true with fine art photography. But the professional still life photographer must often produce an image that works with type. Sometimes a layout calls for a bleed picture with type dropped out, or the image may span only a portion of the spread and the type may run at its side. In either case, the type will add a visual, integral element to the composition, and depending upon how you design your picture, the type will either destroy or enhance its effect.

Many advertisers and editors use nice, clean typefaces like Helvetica or Futura. But even so, the presence of type creates a very organic, busy atmosphere, and when selecting the elements that will compose your picture and determining their placement you should be aware that the type will make an extraordinary difference. Sometimes I add a napkin with a design or some other patterned cloth to a set just to create that organic tension so that the other objects and colors in an image don't appear flat. But if type will be used nearby or within the picture, that need has already been fulfilled, and if you add too many busy elements the photograph will be disjointed and confusing. Inset pictures also create a busyness and, along with type, their placement should be considered when planning the overall composition.

Unlike fine art photography, which is basically an independent endeavor, advertising and commercial photography really require team effort. To make a successful advertising photograph you must be aware of the way it will ultimately be used. You must ask yourself some questions—will type be added, where will it be placed, what face will it be, and what will it say? Answering these questions beforehand may save you a lot of time and headaches, for all of these aspects will effect the way you should design your image and the impact it will have. Often a photograph that is designed to accompany a bold, strong typeface looks unfinished by itself. Although the image may be professionally lit, carefully arranged, and aesthetically appealing, it may give the sensation that something is missing. This is because the photographer has used the type as an element in his planning and without it there is a sense of imbalance. An advertising photograph is not presented framed on a museum wall so not only must it be a good photo, the type must be clean and the layout of the page must be intelligent. Unfortunately, if an art director or client fails in one of these areas, an image that a photographer has carefully constructed may fall flat on the page. So it's good to be aware of all the aspects of planning an ad so that your photograph can work well within the overall scheme. That way you needn't worry that the type will be used in a manner that will be detrimental to your image. Instead you can plan the best way to take advantage of the positive effects of type.

A FOREGROUND FILLED WITH COPY

When Citibank Investments asked me to shoot their ad, they suggested I use a golden egg placed in a nest. I felt that such an environment would be much too obvious so I convinced them to let me try a more original approach, and they were quite pleased with the results. I thought the egg would be much more effective on a precipice, a concept which seems to go well with the notion of investing, anyway.

I placed a solid brass egg on a black pipe and hung a sheet of black, ribbed rubber beneath. One of my primary concerns was creating a space for all the copy that was to go with the image, and the ribbed rubber proved to be the right thing. It was dark enough that the small type being used could be quite legible when the printer dropped it out as white. At the same time, there were subtle horizontal highlights on the ribs that gave the area a kind of texture. If there had not been type in this shot, I

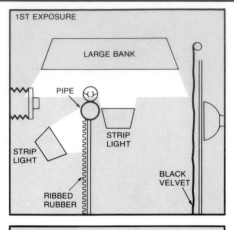

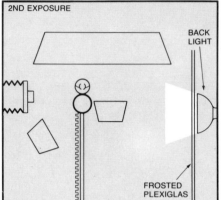

would have put something on the rubber similar to the use of the shoelace in the foreground of the shot of the red Gucci shoe (page 45).

Since the egg was brass it reflected light from all directions and I used four separate light sources to take advantage of its reflective nature. A 5 × 6-foot bank light positioned above the set created a massive highlight on the upper portion of the egg, and a strip light behind and underneath the egg created a thin light around the bottom curve. A backlight created a glow that clearly defined the edges, and a strip light in the front put a highlight on the linear lines of the ribbed rubber, on the egg, and on the base of the pipe. I photographed the foreground and background in separate exposures, using black velvet between shots. The combination of the brass egg with its extraordinary reflective qualities and the varied light sources created a strong visual statement.

Foreground elements recorded during first exposure against black velvet backdrop

Glow backlight recorded during second exposure

Backlight helps separate egg from background

Plastic pipe spray-painted black

Large highlight from large overhead bank

Highlight from front strip light

Edge highlight from strip light just behind egg

Highlight from overhead bank

Thin highlight from front strip light

Foreground of black ribbed rubber provides a large area for type to drop out as white

Thin linear highlights provide a subtle pattern that does not detract from type

Highlights on ribs from front strip light

A FOCAL POINT FOR A TYPE LINE

I decided to contrast Corning's pastel lenses with a very electric pink eyeglass frame that the copy could be dropped into. I removed the arm of the frame because I wanted to keep the design as uncluttered as possible. Though the type was very light and delicate, its position in the frame made it stand out. The copy became an integral part of the design, and harmonized with the rest of the image.

The lenses were arranged by trial and error on a sheet of frosted Plexiglas. I placed different-sized lenses in overlapping positions to provide variations in color. It was like creating my own puzzle of colors and shapes. I used mostly violet and blue lenses, and had to add some brown lenses to complete the Corning Line. The

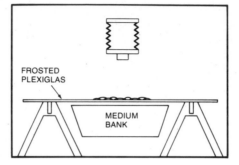

photo would have been more successful without the darker shades, but in advertising you can't always tamper with the client's product to improve a shot.

I shot straight down and lit the set with a bank placed beneath the Plexiglas. Usually when I shoot straight down, I actually angle the lens a bit to allow for the overhead light. In this case, however, the light was beneath the set.

Darker lens here and at lower right balance the frame

Lighter lenses prevail to avoid overwhelming frame

Bright frame stands out from pastel lenses

Single eye used to create one focal point for type

Background of frosted Plexiglas lit from beneath

Lenses overlapped to give a more casual feel

Compatible blues, tans, and purples used

Arm removed from frame to simplify scene

If you think Corning
just makes lens blanks,
come to Opti-Fair '82.
It could change your
whole outlook.

A DYNAMIC ANGLE FOR STAGGERED LABELS

I was immediately reminded of a freight train when I looked at this Sony portable radio, so I decided to play upon this impression, creating a sense of the radio zipping along like a little train. At the same time, I needed an arrangement that would let the art director put in the labels and lines that point out the radio features.

The radio was placed on a sheet of ribbed rubber, which was spray-painted an identical blue-gray. I wrapped the rubber into a cylindrical shape so it fell off at the back, and positioned it across the picture plane in a diagonal, rather than horizontal, line to add to the sense of movement and dimension. I shot from above with a wide-angle lens positioned over a corner of the radio so it would taper off toward the back.

A strip light in the background, shining through frosted Plexiglas, created the diagonal glowing line, which also heightens the motion effect. I used a front light and side light to brighten up the knob and dials and to illuminate the controls inside the dust cover where the cassette is placed. The light was essential in order to make the type visible on the head phones and all the areas of the radio. I shot the foreground and background separately in a double exposure to protect the different lighting effects in each area.

The ribbed rubber in the foreground and the black area in the back provided perfect areas for the type to be reversed as white. And the radio's dynamic diagonal position made it possible for the labels to be placed in an interesting, staggered arrangement.

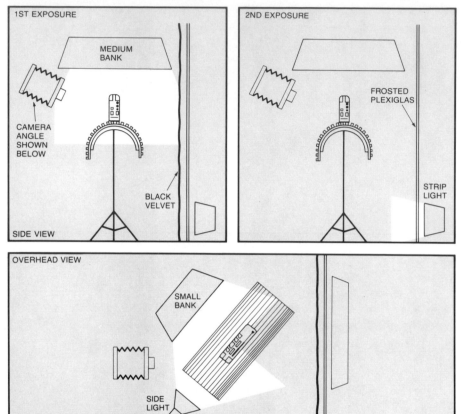

Dark back- and foregrounds allow type to be dropped out as white

Wide-angle lens causes lines to recede rapidly heightening dynamic perspective

Ribbed rubber spray painted the same color as unit

Ribbed rubber's curved shape makes it fall off rapidly in back

Side light makes even labels under dust cover visible

Top light makes unit's top controls and labels clearly visible

Smaller side light makes unit's controls and labels visible

Foreground elements recorded during first exposure against velvet backdrop

Glow from back strip light recorded during second exposure

Glow diffused by frosted Plexiglas

Diagonal arrangement creates a dynamic thrust

Diagonal arrangement also allows for staggered positioning of type

Sorry, no turntable.

Sorry, no turntable.

You're looking at the Sony Soundabout AM/FM Stereo Cassette-Corder.

As the name implies, it offers AM/FM stereo, it records and plays back cassettes.

This little machine does everything your home stereo does. Except play records.

It took major technological advances in micro-

circuitry to pack so much into an audio system that you could hold in one hand.

So why talk about what this Stereo Cassette-Corder doesn't have? Perhaps it's because we've always believed the impossible is possible.

No, it doesn't have a turntable.

Yet.

SONY®
THE ONE AND ONLY

A CROSSED-OUT SUBJECT

I made this shot to advertise Proctor-Silex continuous cleaning toaster ovens. Rather than feature the oven itself, the agency decided a used steel-wool pad would make a much stronger statement juxtaposed against the copyline, and the bright red X that would be superimposed over the pad in the final printed ad. Nobody likes to clean ovens and the vision of a sudsy pad with an X through it would attract consumers to the advantages of a self-cleaning oven.

I shot the cleaning pad on a type of Formica similar in appearance to stainless steel, and ran the grain from back to front to create an illusion of depth. I placed the pad at an angle, not only to make it look more dynamic, but also to allow for the X. If the pad was aimed straight on to the camera the legs of the X would hide the pad's corners. I whipped up some soapsuds for the steel wool, and dropped some glycerine onto the Formica with an eyedropper. Some of the soapsuds were allowed to dribble down into the glycerine to vary the effect.

A top light was positioned so that it intersected the steel-wool at midpoint. This resulted in a fall off in the back, with the light modulating from white in the foreground to black in the far background. I used a wide-angle lens to heighten the sense of perspective and create a dramatic quality. This approach allowed a very ordinary subject to become an interesting study of texture. The modulated, grainy gray background, the twined, dark gray steel wool of the pad, and the soapsuds and glycerine all worked to provide a highly textural image. I purposely made the image totally gray to heighten the impact of the red X.

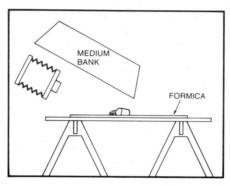

MEDIUM BANK

FORMICA

Dark area permits brand name to drop out as white

Background of Formica simulates stainless steel

Grain run front to back for more perspective

Red X superimposed later by artist

Light drops off rapidly at back for more dramatic effect

Only neutral colors used in shot so that red X stands out

Pad angled to follow lines of X

Wide-angle lens gives pad a more dynamic perspective

Soap suds applied to pad and glycerine

Pools of glycerine with bubbles made with an eyedropper

Pool positioned so that it falls mostly between the legs of the X

Proctor-Silex introduces Continuous Clean toaster ovens.

People have always had a love/hate relationship with their toaster oven. They love to make things in it. And they hate to clean it.

Proctor-Silex® has changed all that. With toaster ovens that have Continuous Clean.

Continuous Clean is a remarkable inside coating by Du Pont.

It cleans the oven while the oven's cooking. And lets you wipe away any splatter with a sponge when you're done.

Gone is the scrubbing.
Gone is the scouring.
Gone is the swearing.

What's left is a toaster oven you won't think twice about using. For baking or toasting or just keeping a hot dish warm.

P.S., you won't think twice about broiling, either.

P.S.
™ **Proctor-Silex**

A SHOT WITH ANOTHER SET IN

For Tia Maria, I was asked to create a moody shot of the label that possessed a golden, warm quality. The problem was that the label was actually a very cold-toned gold, and it was necessary to devise a way to communicate a much warmer illusion.

I solved the problem by putting an orange gel over the camera lens to give the bottle a warmer hue. I could have gelled each light individually, but gelling the lens is a quicker way to achieve the same effect. I wanted a dynamic perspective with the label filling most of the frame, so I shot with a wide-angle lens looking down on the bottle. The label was lit diagonally with a focusing spotlight. The sides were lit with two small square lights to accent the lines on the label and to highlight the neck of the bottle. The light on the label was much more intense than the sidelights. A back light shining through frosted Plexiglas created the glow around the neck. All of the lights were carefully directed to allow the area at the base of the neck to go dark. This allowed for the smaller photograph which was stripped in later. You can see the two separate photographs below.

I shot the insert with various glasses but the company preferred the image of two identical glasses, which provided an even balance. The insert was shot with a top light, side light, silver cards behind the glasses to light the liquid, and two silver cards on either side of the bottle to create a rim light and separate it from the background.

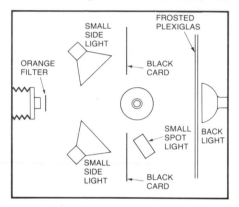

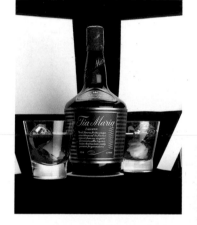

Inset photographed separately and stripped in by printer

Glow from backlight behind frosted Plexiglas

Area allowed to go dark to accommodate inset and line of drop-out type

Dramatic tapering of bottle and label created by using a wide-angle lens at high angle

Area allowed to go dark to accommodate drop-out line of type

Highlight on neck from side lights

Highlights on shoulder from side lights

Overall warm tone comes from orange gel over lens

Brand name lit with small spotlight, creating a main focus

Spotlight's intensity makes area less golden than rest of shot

For the delicious hours between dessert and dawn.

Tia Maria

LIQUEUR

World famous for the unique smoothness of its flavour, derived from a Jamaican recipe which is guarded

THE WORLD'S FINEST COFFEE LIQUEUR

Great recipes for Tia Maria could fill a booklet. Send for yours now. It's free. W.A. Taylor & Co., P.O. Box 528250, Miami, Florida 33152.

A TYPE LINE THAT COMPLETES A SUBJECT

I shot this hanger and perfume bottle for a double-page spread in *Women's Wear Daily*. The Louis Feraud logo was to be a prominent element, so I asked a model maker to construct a hanger. He coated the hanger with a lacquered, high-polish finish, and die-stamped the type in a central position with gold leaf. The hanger had no cross bar, which allowed space for the line of type to be stripped in later for the ad. The hook was gold-plated, as was the piece of chrome from which it was hung.

I placed the hanger on a piece of ribbed rubber, which was sprayed white for a strong contrast, and I raised the whole set up at a slight angle so that the hanger's face would read dark black. I used a top light from behind to cast a highlight along the hanger's top edge. Since the logo was a key element I accented it with a small gold fill card. I arranged the top light to cast a shadow along the base of the hanger to provide a sense of dimension. The sides of the hook were illuminated by light bouncing off the ribbed-rubber background.

The small bottle in the image was photographed separately and later

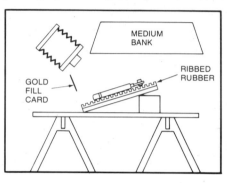

stripped into place because, in reality, the bottle was too large and would have otherwise overpowered the hanger. I did want the bottle to look as if it were shot at the same time, though, so I tried to shoot it with the same quality of light as the hanger. I shot it on its back, lit by a medium bank with two fill cards to the left and right, on a medium gray background. I wanted to modulate the light on the face of the black glass, and placing the bottle on its back resulted in a pure black outline around the edges with the highlights created by the two dull cards. The shadows beneath the bottle were added later by a re-toucher.

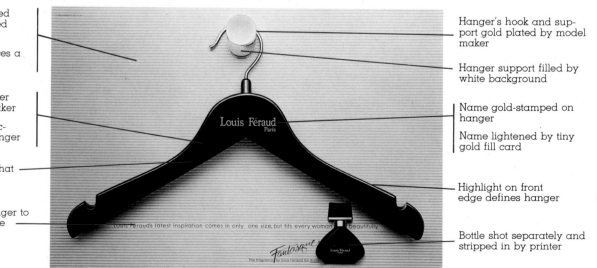

Background of ribbed rubber spray-painted white

Background produces a very subtle shadow

Special wood hanger made by model maker

Highly polished, lacquered finish on hanger

Hanger angled so that face doesn't reflect

No crossbar on hanger to allow for line of type

Hanger's hook and support gold plated by model maker

Hanger support filled by white background

Name gold-stamped on hanger

Name lightened by tiny gold fill card

Highlight on front edge defines hanger

Bottle shot separately and stripped in by printer

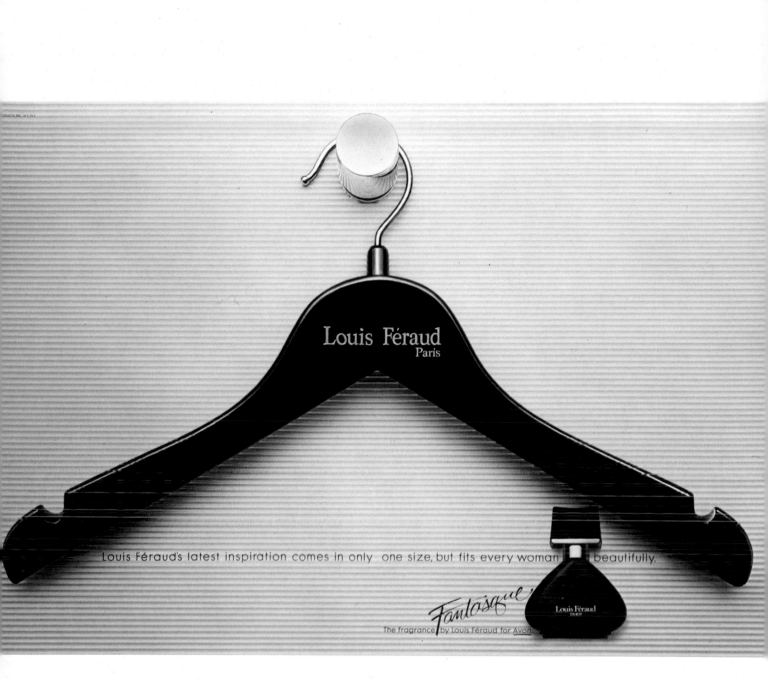

Part Six
STILL LIFES WITH HANDS

A CHAMPAGNE TOAST TO LUFTHANSA

I made this photograph for Lufthansa to advertise their first-class service to Germany and points beyond. I wanted to present a very high-class, elegant image that suggested the serenity of flight. I chose a hand model with slim, tapered fingers to hold the glass, which was filled with bubbly champagne. The airplane was rented from a model maker who had reconstructed the interior of a 747.

The placement of the glass was crucial in creating the illusion that the light was coming in through the window. Since the glass was cylindrical, it reflected light from all directions. I had to position it very carefully, so I attached the glass to a tripod stand to keep it stationary. In positioning the glass on the stand, I made certain that the Lufthansa logo was centered, and that the window's shape was reflected perfectly around the logo, framing it. An excellent hand model managed to recreate the same position each time I shot. Her hand had to be positioned far enough away from the window so that the light on her fingers wouldn't reflect onto the inside of the pane. She skillfully positioned her thumb to pick up a little highlight on her nail.

A back light, shining through a frosted, milky-colored diffusion material call Lumilux, and then through the window, lit the champagne, and a side light cast a highlight on the right side of the glass and created the rim of light on her finger. I used a black card to cut off the side light illuminating the glass so that it wouldn't hit the window. I just managed to keep the window in focus, even though I couldn't stop the lens all the way down because the flash had to be set on low power to get a duration fast enough to stop the bubbles in the champagne.

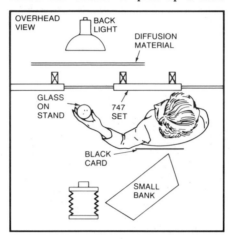

Freshly poured champagne

Bubbles frozen by short flash duration

Lufthansa logo centered

Window's shape is reflected in glass, framing the logo

Finger tip sticks out instead of hugging glass for better line

Less important fingers are obscured by shadows making lighted parts look longer and more graceful

Glass supported by unseen stand

Glass and hand positioned well to one side so image can be used for two-page spread

Backlit diffusion material looks like upper sky

747 airplane set rented from model maker

Highlight on glass from side light

Thumb positioned to get highlight on nail

Thumb and edge of forefinger highlighted by side light

Fingernail perfectly polished

Hand's lines draw the eye toward logo

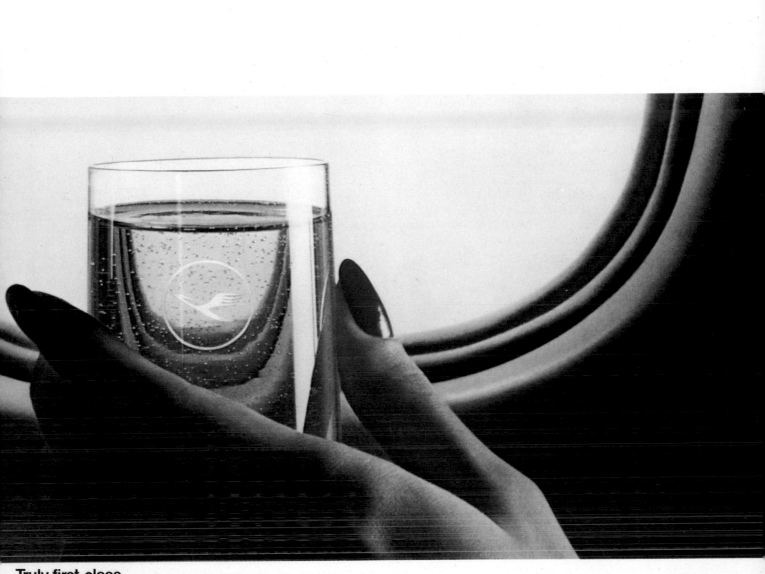

Truly first-class.
A reputation earned on 6 continents, in 71 countries, and 123 cities around the world. ✈ **Lufthansa**

North American Gateways: New York, Boston, Philadelphia, Atlanta, Miami, Dallas/Ft. Worth, Chicago, Los Angeles, San Francisco, Anchorage, Toronto, Montreal. See your Corporate Travel Department or your Travel Agent.

A HAND IN MOTION

I shoot an ongoing campaign for American Express and in this picture I wanted to convey the swift, assured movement of a hand presenting the gold card.

The shot was a difficult challenge for the model, who had to repeat his movements and use precise timing during a time exposure when the movement was recorded. He then had to hold this position while we took a second exposure showing his hand sharply. The card itself was very shiny, and even when matted down it would still glow a bit, so the model had to angle the card away from the light as he moved. To make it easier for him we blocked his hand at the beginning of the move with a light stand, so that the starting point would always be the same. Then he moved his hand very quickly, slowing down as he reached the end point, where another light stand was positioned to halt the motion. The stands were covered with black velvet.

We shot the motion in the first time exposure with tungsten light, using a conversion filter over the lens to balance the film. I used the modeling lights in the overhead bank as the tungsten source. When his hand reached the finishing point, I shut the lights out, took the filter off the camera, and shot the frozen hand with a strobe. When shooting movement it's best to use a dark background, because a light background would overexpose the movement.

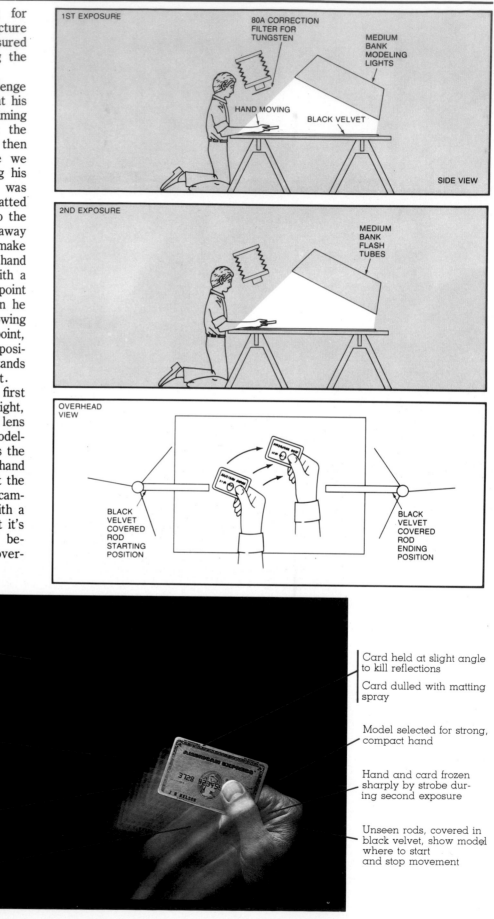

1ST EXPOSURE

80A CORRECTION FILTER FOR TUNGSTEN

MEDIUM BANK MODELING LIGHTS

HAND MOVING

BLACK VELVET

SIDE VIEW

2ND EXPOSURE

MEDIUM BANK FLASH TUBES

OVERHEAD VIEW

BLACK VELVET COVERED ROD STARTING POSITION

BLACK VELVET COVERED ROD ENDING POSITION

Black velvet background prevents overexposure during time exposure

Movement recorded during time exposure with tungsten light

Color during tungsten exposure corrected by filter over lens

Stroboscopic effect created as model's hand made brief, jerky pauses in movement

Stronger image as model's hand slowed down

Card held at slight angle to kill reflections

Card dulled with matting spray

Model selected for strong, compact hand

Hand and card frozen sharply by strobe during second exposure

Unseen rods, covered in black velvet, show model where to start and stop movement

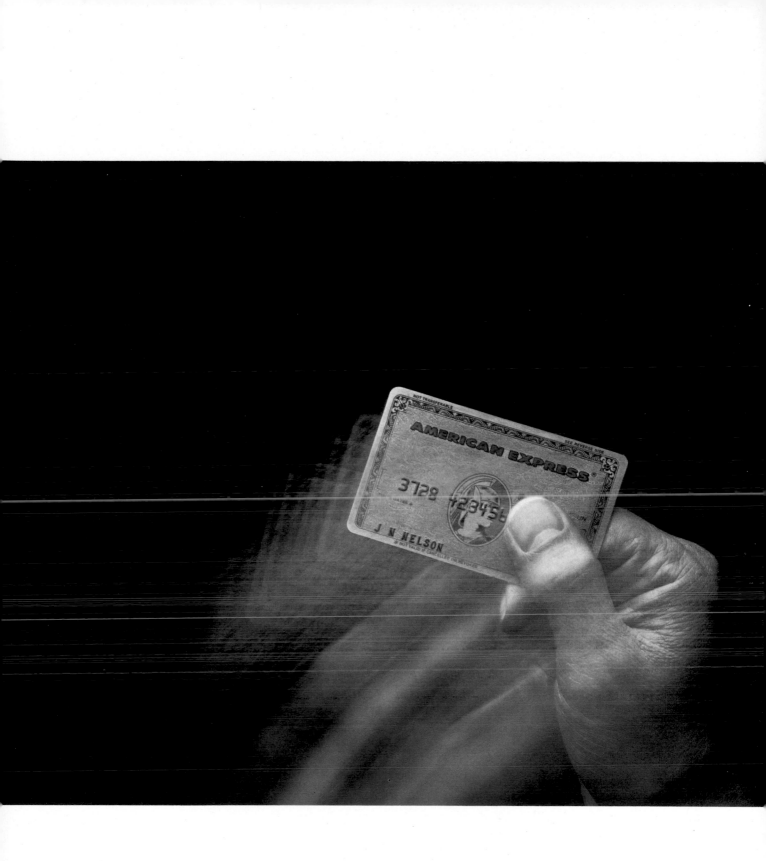

Part Seven
MODEL MAKERS' ILLUSIONS

The key to model making is great model makers, and a great model maker is someone who can make a model that looks real. Most model makers are ex-sculptors who are very artistic and well organized, and they can look at a layout and scale the model to the proper size. A model maker is usually a genius of sorts—and little bit crazy. He has to be able to look at a problem, analyze it quickly, and come up with the right answer. There's little room for trial and error, and the model maker must previsualize and plan so that he doesn't waste the photographer's time and money.

The key word is experience. There's no school for model makers—it's a tutorial kind of education. So it's good to do a little research on the model makers you're using. Be sure that your model maker has studied with someone who knows the ropes, and that he has had enough experience not only to make decisions but to acquire the right materials to make the image work. Some model makers are good at some things and mediocre at others—be certain that you hire the right person for the right job.

Model making is based on illusion, and many times the illusion that must be created defies the laws of physics. When the illusion can't be created with the lens of the camera, or by using design, I usually turn to a model maker. If an effect can't be done in camera, something has to be altered either in pre- or post-production. Retouchers are another part of this process.

An important factor in model making is constructing a sense of perspective that the camera is incapable of creating. The product—always the hero of still life advertising shots—is placed before the camera to determine the setup. Then the model maker can figure out the sizes and dimensions of the other elements in the image. If you don't set up the shot in front of the camera first, many times the perspective will come out wrong. Often when a normal lens is used on the product to make it look realistic, the background won't have enough perspective. So the model maker will build a background with forced perspective, generally foreshortened to create spatial drama. This was the case in the Sony shot (pages 130–133), where the room was built with the walls angled back to make it appear longer than it actually was.

Lots of times art directors have an idea in mind that simply breaks the laws of science. The only way to achieve the desired effect is to find an experienced, bright model maker who will save the day. He has to know a lot of little details—like the fact that certain kinds of acrylic yellow and crack when dry—and he must be enthusiastic about creating a world that will accommodate the photographer's vision. They have to be sticklers for perfection, because the tiniest flaw will make the difference between a set that looks real and one that is laughably fake. The model maker can make or break your photograph, so it's worth taking the time to seek out someone you can fully trust, who has a good understanding of the product and the theme you are trying to convey. He must be able to combine wizardry with artistry to make your image a success.

A HEAVENLY SETTING FOR PORTABLE STEREOS

When General Electric asked me to make a photograph to accompany the copy "Choose your escape route," they asked me to create an image conveying the carefree feeling of being up in the clouds and away from it all. I wanted a frothy, airy kind of scene in which the product would appear to be floating serenely.

I asked a model maker to spray a sheet of curved, frosted Plexiglas blue at the top, gradually feathering to light blue and then white, which you can see in the smaller picture here. The bottom portion remained translucent, allowing light through to illuminate the set. I positioned the three stereos on the level area of the Plexiglas, which I then covered with white cotton batting.

The headphones were suspended above the set with clear nylon threads that would not be visible in the final image. The wires connecting the headphones to the stereos were fairly light, so the model maker replaced them with heavier, black-coated copper wire that could be easily bent into a flowing curve that would retain its

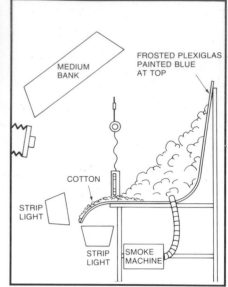

shape.

A smoke machine, placed off to one side, provided the billowing white clouds. The smoke, created by dry ice, was pumped through a hose. A flat was positioned to direct the smoke back into the picture and prevent it from floating out of the frame.

This shot was top lit and bottom lit. I also front lit the set with a strip light to brighten up the stereos, and maintain the detail of the switches and numbers. I positioned the camera a little above the set so the controls on the tops of the radios would be visible.

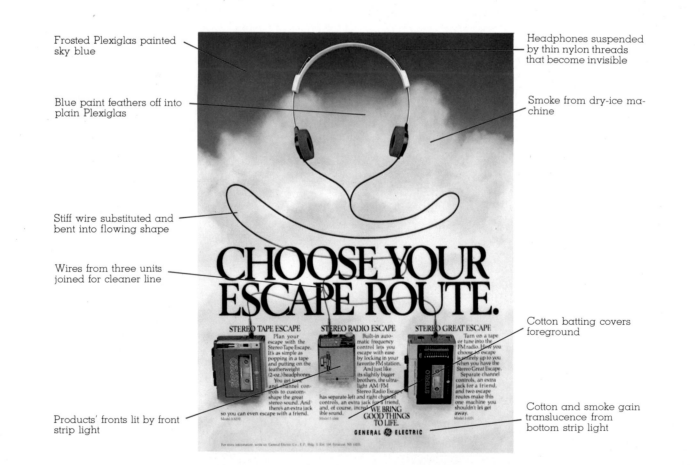

Frosted Plexiglas painted sky blue

Blue paint feathers off into plain Plexiglas

Stiff wire substituted and bent into flowing shape

Wires from three units joined for cleaner line

Products' fronts lit by front strip light

Headphones suspended by thin nylon threads that become invisible

Smoke from dry-ice machine

Cotton batting covers foreground

Cotton and smoke gain translucence from bottom strip light

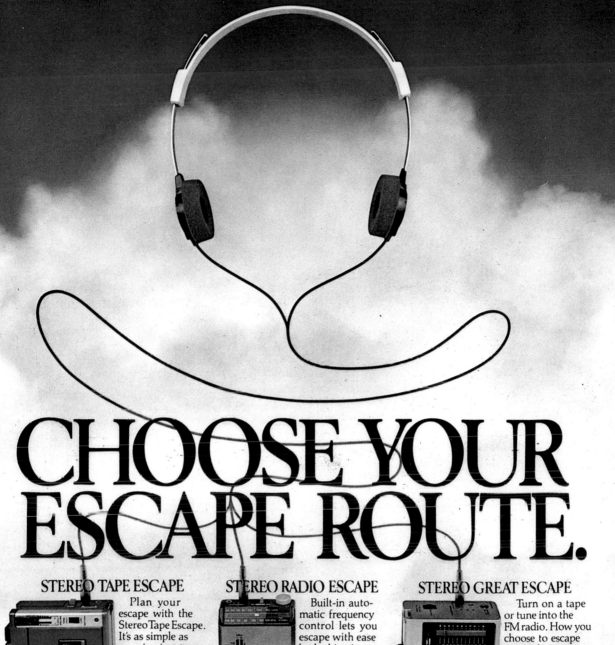

CHOOSE YOUR ESCAPE ROUTE.

STEREO TAPE ESCAPE

Plan your escape with the Stereo Tape Escape. It's as simple as popping in a tape and putting on the featherweight (2-oz.) headphones. You get tone and channel controls to custom-shape the great stereo sound. And there's an extra jack so you can even escape with a friend.

Model 3-5270

STEREO RADIO ESCAPE

Built-in automatic frequency control lets you escape with ease by locking in your favorite FM station.

And just like its slightly bigger brothers, the ultra-light AM/FM Stereo Radio Escape has separate left and right channel controls, an extra jack for a friend, and, of course, incredible sound.

Model 7-1000

STEREO GREAT ESCAPE

Turn on a tape or tune into the FM radio. How you choose to escape is entirely up to you when you have the Stereo Great Escape.

Separate channel controls, an extra jack for a friend, and two escape routes make this one machine you shouldn't let get away.

Model 3-5271

WE BRING GOOD THINGS TO LIFE.

GENERAL ⒼⒺ ELECTRIC

For more information, write to: General Electric Co., E.P., Bldg. 5, Rm. 139, Syracuse, NY 13221.

DUMMY HANDBAGS TO SET OFF THE REAL ONE

The theme for these handbags, like the Gucci pens (page 49), was "Gucci stands out in a crowd." I thought long and hard about how to illustrate this concept in a sophisticated manner and arrived at this idea based on a bas relief. I wanted the bags to look as if they were cut out of stone, with only the central element having color. To accomplish this I first tried spray-painting actual bags a neutral brown and then arranging them around the Gucci bag. That shot, shown here, was not as successful as I would have liked because the symmetry was rather confusing, so I decided to have a model maker construct some cardboard handbags, all of the same color and thickness, which I could arrange in a more regimented composition. This photograph was much more effective.

Creating this shot was like putting a puzzle together. Using bags of different sizes made the design more interesting and created tension be-

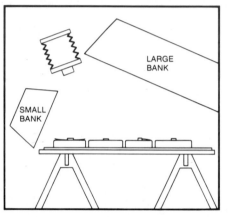

tween larger and smaller shapes. When you're dealing with flat surfaces and flat pictures, it helps to utilize design and lighting to suggest a feeling of depth. I used dark brown model-made bags because I knew their color would cause them to recede while the lighter bag advanced. I also chose the brown to complement the logo on the Gucci bag.

The set was toplit with a large bank and I also used a fill light in the front. Because all the bags were of the same thickness, I had no problems with the depth of field here. The concept was conveyed without being oversimplified, and the unique features of the Gucci bag were emphasized by its strong contrast to the other elements in the image. Unlike the first photograph, which resulted in too much tension, the clean organization of the second shot enhanced the product, placing it clearly and elegantly in the limelight.

Bags and background painted a subdued medium brown that goes with main subject

Bags of differing sizes introduce a controlled irregularity

Flat overall lighting from overhead bank

Light-toned subject stands out from darker surrounding bags

Subject placed off-center for more dynamic effect

Highlight from front fill light

Model maker's cardboard bags repeat design of main bag for harmonious effect

All bags kept same height to avoid depth-of-field problem

Bags arranged to avoid long channels running the entire length of the image

Strap arranged to create an interesting design

Small bag breaks up regularity of pattern

Bag placed upside-down to avoid repeating bag next to it

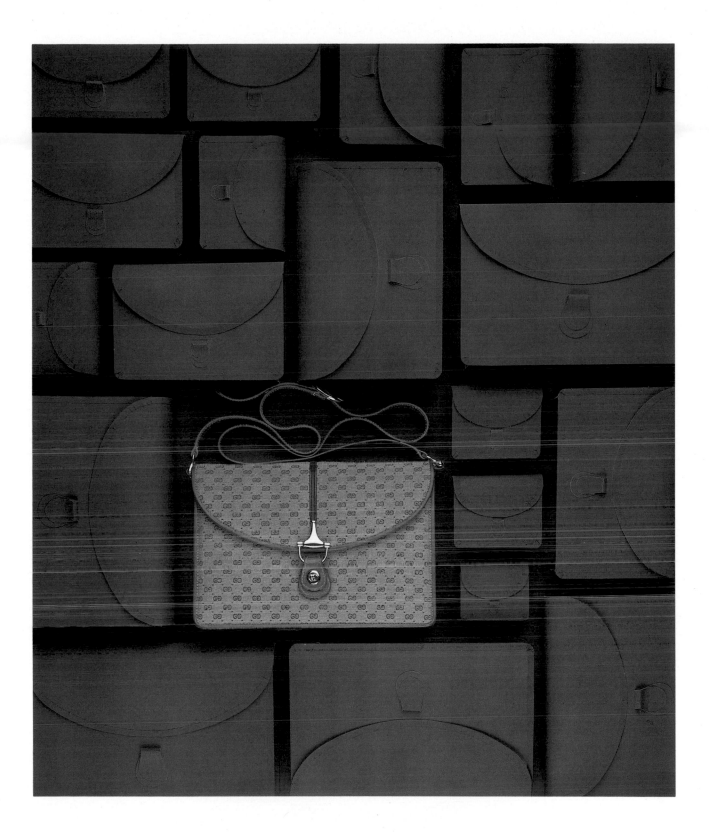

A MODEL CAR FOR LUNCH

The copy for this ad for 3M was to be "We help keep your car from becoming a feast for rust" and the company had a solid idea of the concept they wanted to communicate. They suggested that I use a full-size car and have a giant plate constructed. Thanks to model makers, however, I felt it would be much more efficient to have the parts of the car scaled to the size of a real plate.

The model maker purchased a quarter-scale Porsche kit and modified the parts, making the sections look more generic. He sprayed the door a bright red and added a partially rolled up window, made of plastic. I placed it on the center of the Swiss cheese sandwich. The salad was made of wheels and hubcaps, and I garnished the sandwich with tiny windshield wipers. The straws were made of a miniature muffler and tailpipe attached to silver-painted flex-straws, and positioned in a glass of soda, the perfect place for rust to spread. I chose a short glass that would stay in focus and added some Lucite ice cubes.

I wanted it to appear as if this feast was taking place in a diner so I used typical diner dishes and a Formica background. Because the lines on the dish didn't seem thick enough, I had a potter restrike them so there would be one wide green line and one narrow green line. A home economist baked the bread, which had a beautiful symmetrical line down its center, and I positioned the top half only off to the side for balance.

The shot was top lit, and I also bottom lit the glass by cutting a hole in the Formica beneath it. The top light was positioned to brighten up the silverware and to enhance the reflections on the door and the car window. I used a small white fill card so the shadows beneath the plate wouldn't become too heavy. What could have been a nightmare to produce became a fairly straightforward shot. Once the model maker had provided us with all the components necessary to express the theme, it was simply a question of arranging them in an imaginative manner.

Ordinary food prepared by home economist

Salad made with model car's wheel and steering wheel

Model car door modified to look less like a specific make

Car door painted red to stand out and go with food

Plastic window added and made to look rolled down

Soda bottom lit through hole in Formica

Model car's muffler and tail pipe attached to flex straws

Cut-down glass used to avoid depth-of-field problem

Patterned Formica to suggest diner counter

Front shadows lightened with fill card

Lines added to dishes for authentic diner look

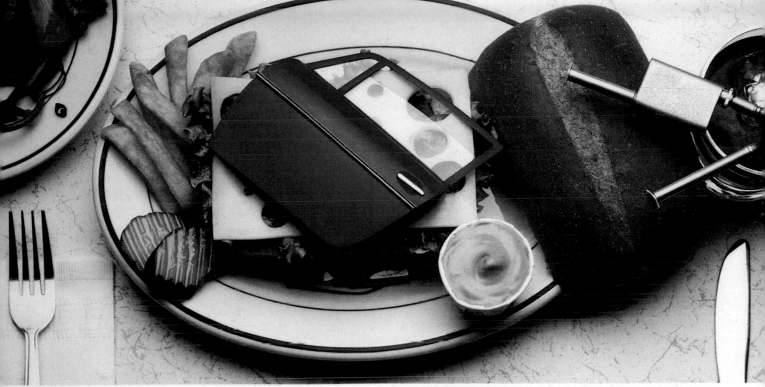

We help keep your car from becoming a feast for rust.

With inflation nibbling away at your purchasing power, the last thing you need is for rust to eat your car.

So at 3M we make automotive products like metal foil tapes that help foil rust attacks on your headlights and rocker panels. We have sealants that can inhibit corrosion from making a main course of your hood and trunk. And we make penetrating sprays to help keep rust from making hors d'oeuvres of your screws and bolts. In fact, we may protect car

parts you've probably never heard of. Because at 3M, we're in the business of hearing. By listening to people's needs, we continually develop innovative solutions like our army of products that armor cars against rust. In addition, we make anti-glare coatings, sound-dampening tapes and adhesives that prevent your car's parts from coming loose.

In fact, 3M has pioneered over 900 products to serve the needs of the

transportation industry.

If you would like a free 3M Transportation and Maintenance Brochure, write us today. **Department 010101/3M, P.O. Box 4039, St. Paul, MN 55104.**

Or better yet, let us hear from you right now. **Call toll-free: 1-800-323-1718,** Operator 002. (Illinois residents, call 1-800-942-8881.)

3M hears you...

FRACTURED LETTERS FOR A CORPORATE BREAK-UP

I made this ad for Merrill Lynch to illustrate the break up of AT&T. It seemed fairly simple at first, but sometimes the effects that advertisers want to achieve defy the laws of physics and are not realistically possible. That's where the model maker—a lifesaver for the still life photographer—comes in.

Since I needed to shoot fairly straight down on the letters so they could be easily read, I couldn't create the perspective with the lens and lost the foreshortening effect that the art director wanted in the ad. Instead, perspective was built into the walnut

gavel's head so it appeared that I was shooting across rather than down. The end of the gavel head closest to the camera is a good bit larger than the other end.

The model maker constructed the letters out of plaster, roughened the surface for more texture, broke them apart, and then airbrushed the pieces gray. I placed the pieces on a sheet of blue-gray slate that I had bought from a quarry some time ago. The

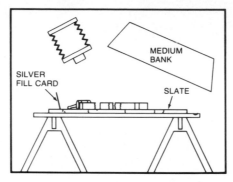

slate was moistened with mineral oil to create a bit of a sheen and provide a richer surface and sharper reflection.

I lit the shot with a very low top light to create dramatic shadows and used a small fill card to lighten the head of the gavel. The foreground was left dark so that copy could later be reversed out as white type. I shot with a very wide-angle 121mm lens to make the perspective even more sweeping and dramatic, so the picture actually had two perspectives: the one from the camera lens, and the perspective built into the gavel.

Letters molded in plaster and then broken apart

Texture on letter surfaces from scratching

Letter pieces airbrushed a uniform gray tone

Chips added to heighten the effect of breaking

Deep shadows on letters' front edges created by low back position of light

Front edge allowed to go dark to allow for drop-out type

Wide-angle lens heightens perspective by making image's lines recede rapidly

Background of rough-hewn slate complements texture of letters

Sheen on slate from coating with mineral oil

Letters arranged so that break is obvious but they are still readable

Back of gavel head made smaller than front to create illusion of perspective

Front of gavel lit up with small silver fill card

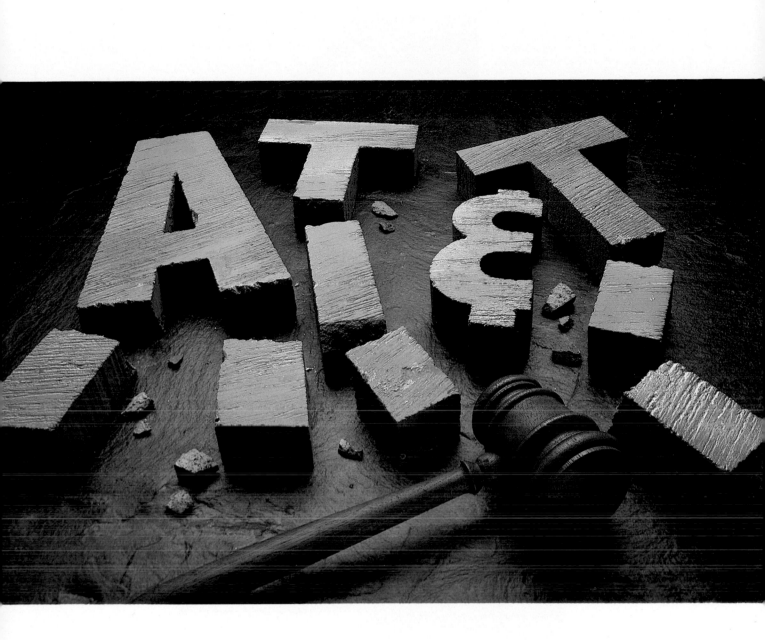

A STAGED AIRPLANE CHRISTENING

I wanted to make a dynamic shot for TWA using a bottle of fine champagne in the image. The setup was rather tricky and required a bit of complicated construction.

The airplane was made from a 60-inch plastic sphere with three holes drilled in the nose. A model maker pre-broke some champagne bottles and fastened the pieces into place with armature wire. I wanted to create the illusion that the glass was actually breaking and shattering against the nose of the plane. The base of the champagne bottle was supported by a camera stand and a model on a stepladder reached his hand down to the set and posed as if he were actually striking the bottle against the plane. A red ribbon, backed by a strip of thin sheet metal so it could be easily curved, created the illusion that it was trailing behind, guided by the force of movement. A tiny piece of monofilament (later retouched out of the image) held up the end of the ribbon.

To provide the splatter of liquid, I initially tried hooking up compressors and hoses, but filling a bucket of water and throwing it through the holes in the airplane nose worked better. (The

holes were hidden by the bottle.) Sometimes the simplest solutions are the best, and in this case the force of water was much stronger and more random when it came bursting from a hand-held bucket.

I used a plastic shield over the lights to protect them, and prevent water from causing an explosion. The bottle was bottom lit, and sidelit for highlights. A strip light pointed at thunder gray seamless created the halated background. Because the movement of water in the foreground and background would have resulted in registration problems in a double exposure, the shot was made in one exposure (although we did many takes).

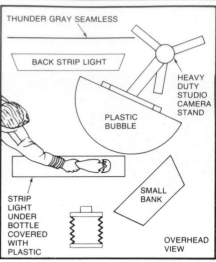

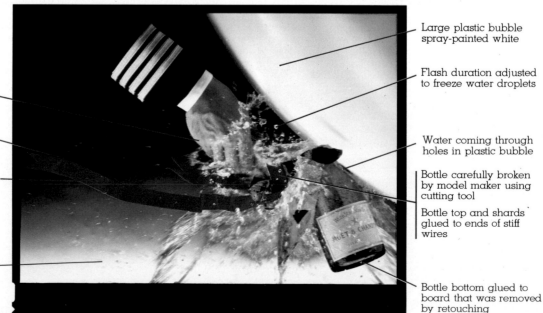

Hand lit by strip light from below

End of ribbon held by fine nylon wire

Stiff but moveable ribbon created by laminating thin sheet metal between two ribbons

Glow from strip light aimed at backdrop paper

Large plastic bubble spray-painted white

Flash duration adjusted to freeze water droplets

Water coming through holes in plastic bubble

Bottle carefully broken by model maker using cutting tool

Bottle top and shards glued to ends of stiff wires

Bottle bottom glued to board that was removed by retouching

A FUTURISTIC EFFECT IN FIVE EXPOSURES

When *PC* magazine asked me to shoot a computer that measures the direction and speed of the wind, I decided to create a surreal, otherworldly kind of set. The product is used to determine where to locate windmills that generate electricity—the computer collects information over the course of a year and then the data is processed by another computer which indicates whether it's feasible to install the windmill. I thought the scientific, high-tech character of the product would be best expressed by an image that conjured up the eeriness of outer space, suggesting a futuristic sense of mystery.

The computer itself was rather drab so we constructed a wall in front of the wind gauge and weather vane and filled it with some switches, meters, and lights (wired with six-volt batteries to brighten them up) to give it more character. Although all pictures are combinations of design and technique, this was one image in which the elements fell into place

quite easily while the technical aspects required precise orchestration and a good deal of forethought. In many of my pictures, design overpowers the technical aspects, but here the opposite is true. Even so, a good photograph is made up of both great design and great technique, and the viewer shouldn't be able to tell where one stops and the other begins.

I made the shot with five exposures. One exposure of the entire scene was made against a black velvet backdrop using daylight film (which is balanced for strobes). A small side light cast a highlight on the weather vane and a strip light placed in the low foreground lit the bottom of the vane and cups, brightened the red ribs on the black ribbed rubber, and illuminated the dials. I used a silver card on the left to provide highlights on the vane. I had difficulty lighting up the inside of the cups so I used a card in the side light to help kick lighting to make each cup dis-

tinct.

Next to capture the motion of the wind velocity gauge, I placed a filter over the lens and made a time exposure with the tungsten modeling lights in the overhead bank as we rotated the gauge. This ensured a continuous swishing movement in the final image, rather than a broken, stroboscopic effect. I also masked the front of the set with black velvet during this exposure. In a third exposure, I removed the velvet backdrop and captured the glow at the horizon, which was created by a strip light covered with blue gel and placed behind a sheet of frosted Plexiglas. In the fourth exposure, I dropped in the stars and moon mask, which was a piece of black paper with small holes and a crescent cut in it. I used a star filter over the lens to give a twinkling effect. I placed a bank behind the mask and flashed the light through it. Finally, I turned on the little lights on the board and recorded them during a fifth, time exposure.

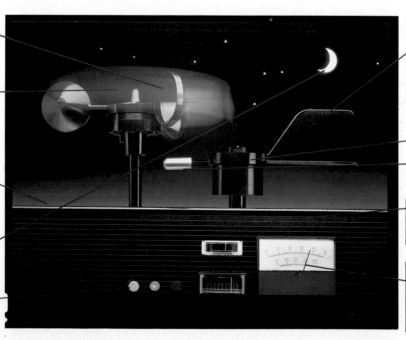

Wind vane, speed gauge, and control panel recorded during first exposure with background covered in black velvet

Movement of wind speed gauge recorded during long second exposure with background and foreground covered in black velvet

Blue glow from back strip light recorded during third exposure with frosted Plexiglas backdrop

Second back light shining through stars-and-moon mask recorded during fourth exposure

Small, battery-powered lights recorded during long fifth exposure

Actual wind vane and speed gauge cleaned and polished for shot

Highlights from overhead bank makes vane and speed gauge stand out from background

Highlight from sidelight

Highlight from strip light below

Board covered with ribbed rubber

Pipe atop panel finishes the raw edge

Lights and meters on board create illusion of a control panel

Meter needles glued in setting indicating high speed

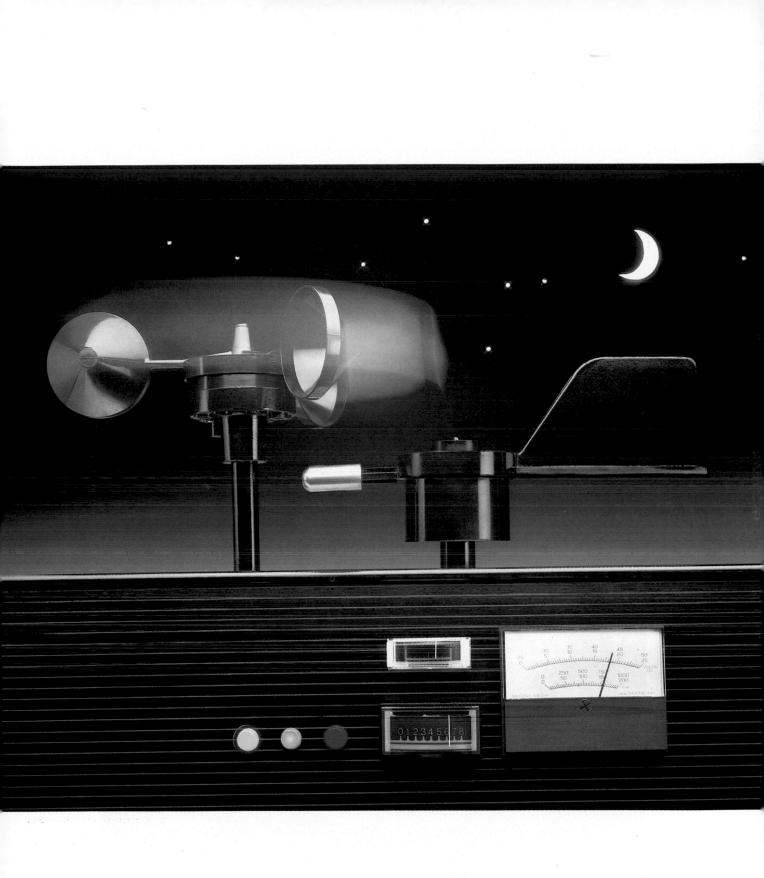

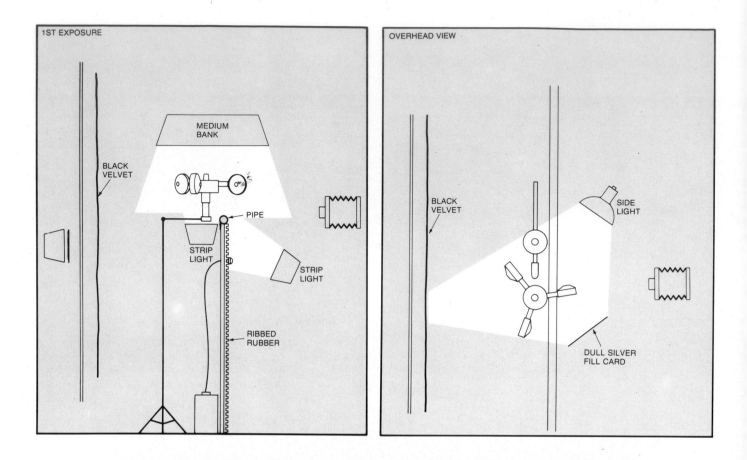

1ST EXPOSURE

BLACK VELVET

MEDIUM BANK

PIPE

STRIP LIGHT

STRIP LIGHT

RIBBED RUBBER

OVERHEAD VIEW

BLACK VELVET

SIDE LIGHT

DULL SILVER FILL CARD

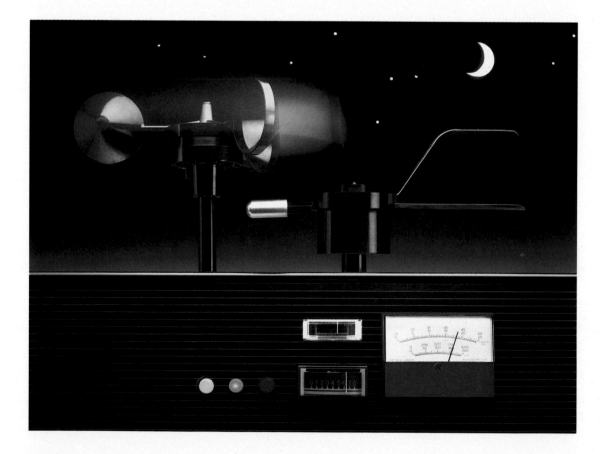

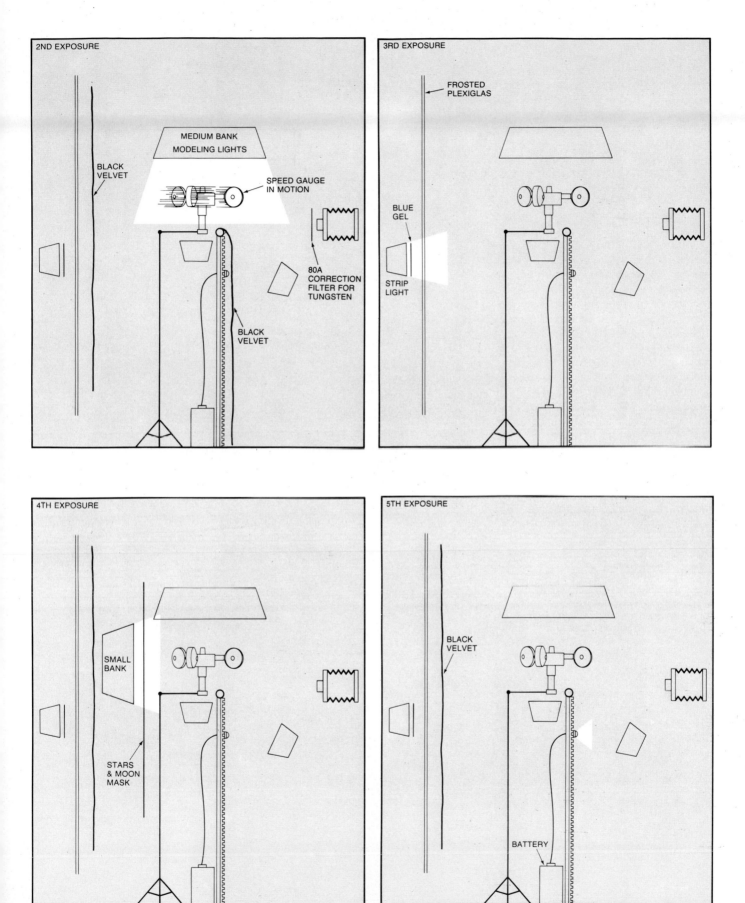

2ND EXPOSURE

BLACK VELVET

MEDIUM BANK MODELING LIGHTS

SPEED GAUGE IN MOTION

80A CORRECTION FILTER FOR TUNGSTEN

BLACK VELVET

3RD EXPOSURE

FROSTED PLEXIGLAS

BLUE GEL

STRIP LIGHT

4TH EXPOSURE

SMALL BANK

STARS & MOON MASK

5TH EXPOSURE

BLACK VELVET

BATTERY

AN UPSIDE-DOWN ROOM FOR SONY

In this collateral ad for Sony and Congoleum I was asked to illustrate the copy "Sony helped Congoleum raise the ceiling on their flooring" by creating a room that was supposed to appear upside-down. I asked a set builder to construct the room after I designed it in-camera.

I placed the Sony TV set in front of the camera with a wide-angle lens in place. Then I roughed out the picture with 2 × 4s, laying down the floor, and the back and side edges. The size of the TV and squares of tile was predetermined, but the other elements were made to order. The walls couldn't be made narrower at the back and wider at the front because the forced perspective would be visible in the floor tiles, so I used a wide-angle lens and shortened the height of the ceiling to about four feet. The moldings were undersized to achieve the proper perspective. The door is actually only a few feet high, and placed about ten inches behind the TV, although it appears much taller and at least a few feet away. The walls were only a couple of feet away from the TV. Because of the juxtaposition of scale, created by the full-sized TV set with fruit and a Betamax on top, the room creates the illusion of being much larger than it actually is.

Ceiling made of diffusion material

Room walls are only about 4-feet high

Scaled-down door about 3½-feet tall

Small, proportionally scaled moldings

Walls and moldings painted colors compatible with linoleum, creating cool feeling

Walls are only about 2 feet from TV

Wide-angle lens makes lines recede rapidly enhancing illusion of depth

Overhead lights illuminate room through diffusion material

Light falls off on back part of ceiling

Overhead lights direct most light to back of room setting off TV

Video recorder and bowl of fruit create a sense of scale

Scaled-down plug and receptacle made by modelmaker

Television lit primarily by two side lights

Chrome base lit by front strip light

Sheen on chrome dulled with matte spray

Sony helped Congoleum
raise the ceiling on their flooring.

In the fall of 1982, Congoleum radically changed their sales picture. It began on August 15, when they offered their dealers the chance to win a wide variety of Sony products. The choice included a Sony Video-Scope™ projection TV, a 26″ console Trinitron,® a Betamax® and much more. What the dealers won depended on how much flooring they had ordered.

By the end of October, retailer purchases of Congoleum flooring had gone through the roof. The Sony $ell-Abration generated over five weeks of business in each four-week period despite a poor economy and without discounting.

So if you want to increase your sales and market share, talk to Sony about incentives. We can help you design the program that's right

for you. The results will have you walking on air.
Contact Paul Lerner,
National Incentive Sales Manager
Sony Corporation of America
9 West 57 St., N.Y., NY 10019
(212) 371-5800

SONY®
THE ONE AND ONLY

Picture simulated.

The ceiling (which became the floor in the final ad) was made of Lumilux diffusion material with lights placed above it. I modulated the light on the ceiling and floor by positioning two rows of two lights each above the foreground area of the Lumilux and aiming them at the back area of the set. A strip light was placed in front of the TV. Two medium banks placed at either end of the strip light lit up the speakers. I sprayed the TV matte to lessen the intensity of the chrome.

The picture of the man was shot separately and stripped into the TV screen later. I photographed him against thunder gray seamless background paper to match the blue-grays of the larger photograph. A light was placed behind him and pointed toward the seamless to create the glow and the main side light was on the left. To make it seem as if he was falling upside-down, we put a stiff wire in his tie and suspended the papers on monofilament so they would seem to be scattering through the air. A stylist also fixed his hair with setting solution so it appeared to be hanging down. Last, but not least, we removed the lenses from his glasses to avoid unwanted reflections.

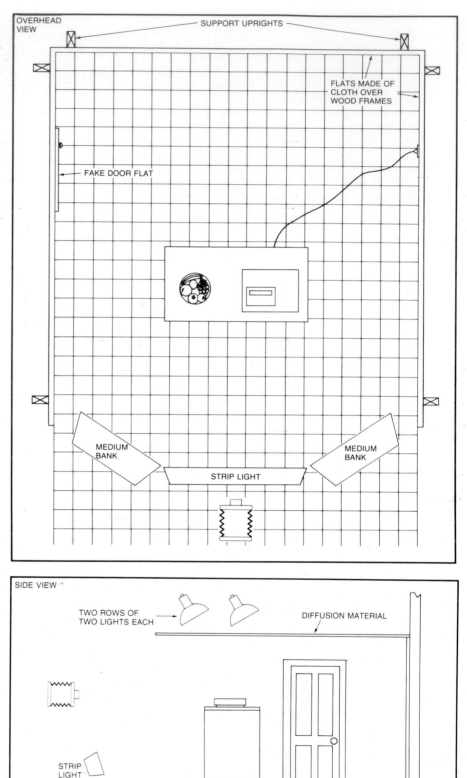

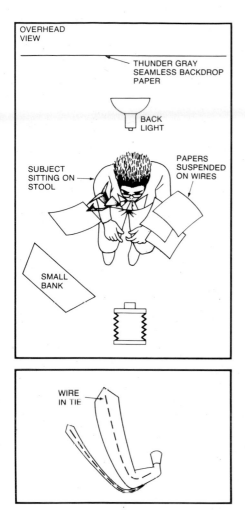

OVERHEAD VIEW

THUNDER GRAY SEAMLESS BACKDROP PAPER

BACK LIGHT

SUBJECT SITTING ON STOOL

PAPERS SUSPENDED ON WIRES

SMALL BANK

WIRE IN TIE

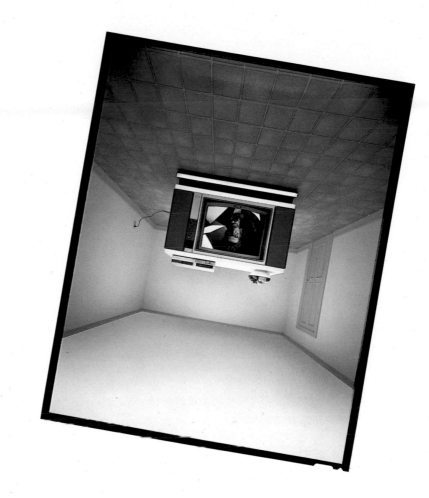

Stylist made hair stand up with hair setting gel

Lenses removed from glasses to avoid reflections

Wire inside tie holds it up

Subject lit with a single side light

Dark gray background paper matches room's colors

Papers held in air by fine clear wires

Glow from backlight hitting background sets man off

ANNOTATED INDEX

Acetate: Sheets of clear plastic which are painted to produce tinted or diffusion effects; 50.

Acrylic drops, 72

Acrylic paint, 46

Angle of incidence: The angle at which light strikes a surface.

Angle of reflectance: After light strikes a surface, the angle at which light is reflected.

Backlighting: Light directed toward the camera from behind the subject; 30, 42, 70, 72, 76, 78, 80, 82, 86, 88, 92, 100, 110, 126.

Bank light: A studio light source made up of numerous individual lights behind a single square or rectangular diffusing fabric. Lights may be used in any combination; 34, 66, 70, 106.

Barn doors: Flaps that attach to the rim of a photo light and can be adjusted to control the amount and direction of light.

Bellows: A folding chamber, generally of light-tight cloth, between the lens and body of a camera, used to adjust the distance or angle between the film plane and the lens.

Black card (or black flag): The opposite of a reflector, used to "absorb" light from an area, and to prevent glare; 30, 72, 110.

Black velvet: Common background material, used for its even black tone and light-absorbing qualities. Its nap holds objects in place. Also used for masking during multiple exposures; 12, 18, 24, 38, 44, 48, 50, 70, 74, 78, 80, 82, 84, 106, 112, 126.

Bleed: A printing term used to describe an image that extends to the trim of the page.

Blocked up: An overexposure or under-developed area of negative that prints as a light, undetailed area.

Bottom light, 22, 28, 44, 60, 94, 120

Bubbles, 68, 70, 82, 88, 98, 110

CC filters: Color correcting filters, available in assorted colors and with densities ranging from .05 to .50; 10.

Color temperature: A system for measuring the color quality of a light source by comparing it to the color quality of light emitted when a theoretical black body is heated. Color temperature is measured in degrees Kelvin.

Complementary colors: A pair of colors that, when mixed together by the additive process, produce white light.

Contrast: The difference between tones in an image.

Cookie: A shaded device made of translucent material to give a mottled distribution of light.

Copy: A publishing term referring to typeset text material and headlines; 42, 44, 48, 58, 90-103.

Density range: The difference between the minimum density of a print or film and its maximum density.

Diffraction: The scattering of light waves as they strike the edge of an opaque material.

Diffuse: Light that has been scattered by reflection or by transmission through translucent material.

Diffused light: Light that produces soft outlines and relatively light and indistinct shadows.

Double exposure: Two separately lighted exposures are often necessary in studio product photography. Black velvet is often used to mask out certain areas during each half of the exposure; 28, 30, 76, 78, 92, 96, 100, 112, 116.

Dull fill card: As a shiny card reflects light strongly, a dull card reflects a softer, more gradual highlight; 34, 40.

Edge lighting: Aiming a light source slightly in front of, rather than directly at the subject, thereby reducing the illumination on the side to a greater extent than on the front, to increase tonal gradation and appearance of depth in the subject; 72, 84.

80-percent black, 36, 38

Elements of tension, 48, 54

Emery paper, 64

Epoxy, 86

Extreme wide-angle lens: To give a monumental impression of even a tiny product, an extreme wide-angle lens will exaggerate the object and its perspective sufficiently to create this effect; 42, 68.

Fall off: When a direct light is used to illuminate a subject, the area where the illumination graduates into shadow is called the "fall off"; 20, 50, 54, 66, 98, 108.

Fill card: A reflective cardboard surface (white, gold, or silver) used to bounce light into dark areas; 26, 34, 50, 54, 66, 68, 72, 82, 98, 108.

Fill light: A supplemental light used to reduce shadows and contrast caused by a main light.

Flag: A square or rectangular reflector attached to a stand. (See also black card.)

Flare: Stray light, not part of the image, that reaches the film in the camera because of scattering and reflection within the lens.

Flatness: Lack of contrast in an image, caused by overly diffuse light, under-development or underexposure, or flare; 48, 58, 94, 102.

Focal length: The distance between the center of a lens and the film when the lens is focused at infinity.

Focal plane: The plane behind the lens where the sharpest image from the lens falls; the plane of the film.

Food dye, 20, 60

Foreground, 28, 108

Foreshortening: A perspective effect wherein the distance between objects appears drastically compressed. Produced at close range by a wide-angle lens, and at long range by a telephoto; 24, 56, 68, 122.

Fresnel lens: A thin condenser lens with a number of concentric ridges on it, used to distribute brightness evenly in spotlights and viewing screens.

Frosted light table: A translucent surface, illuminated from below, set at a convenient working level for use in examination of transparencies, or photographing small subjects.

Frosted Plexiglas: Trade name for a frequently used studio set material. Often illuminated from the rear, or beneath the subject; 22, 88, 94, 96, 78, 100.

Gel: Thin, colored plastic purchased in sheets, cut to fit over a camera lens or light source for tinted illumination; 28, 80, 88, 100.

Glow effect: A neon-like lighting effect, produced usually by placing the subject on or in front of frosted Plexiglas, and directing a light source from underneath or behind the subject; 28, 76, 100.

Glycerine: Viscous, colorless alcohol that absorbs and retains moisture. Used to simulate water or mixed with water, keeps subjects looking wet; 18, 20, 24, 34, 64, 70, 98.

Gobo: A flat, black flag, usually a small circle or square, used to block or direct the light from a photo lamp; 28.

Gray scale: A series of patches, joined together, of shades of gray ranging from white to black in equal increments; 10.

Groundglass: Sheet glass having a granular textured surface, used for focusing panels in cameras, light diffusers in printers, viewers, etc. In illuminating systems, the function of the ground glass is to pro-

horizon line to create a seemingly endless surface; 70, 72.

Tilts: Vertical movements of the front and rear standards of a view camera.

Time exposure: An elegant way to express motion while having the product remain clear is to combine a time exposure, where the shutter is held open for a predetermined length of time, with a strobe shot taken at the end point of subject motion; 50, 112, 128.

Tungsten light: A light bulb containing a tungsten filament and giving light with a color temperature of about 3200 degrees Kelvin.

View camera: A large-format camera, ideal for top quality studio and still life work. Allows precision focusing on its ground glass; generally uses a large-format sheet film requiring minimal enlargement for maximum sharpness; allows for delicate and precise perspective control through lateral, vertical, and angular adjustments of both the lens and the back of the camera.

Vignetting: Darkening in the corners of an image, caused by the intrusion of the lens hood or filter into the subject area.

Edited by Don Earnest and Marisa Bulzone
Designed by Jay Anning
Production Manager: Ellen Greene